Rough Point

The Newport Home of Doris Duke

Written by

A. Bruce MacLeish and Pieter N. Roos

CREDITS

© 2015 Newport Restoration Foundation.
All rights reserved, including the rights to reproduce
this book or any portion thereof in any form.

ISBN: 978-0-9725588-2-2

Newport Restoration Foundation
51 Touro Street
Newport, Rhode Island 02840
Tel: (401) 849-7300

www.newportrestoration.org

Book Design: Darcy Magratten
Project Coordinator: Kristen Costa
Printed at Meridian Printing, United States

Newport Restoration Foundation

ROUGH POINT

The Newport Home of Doris Duke

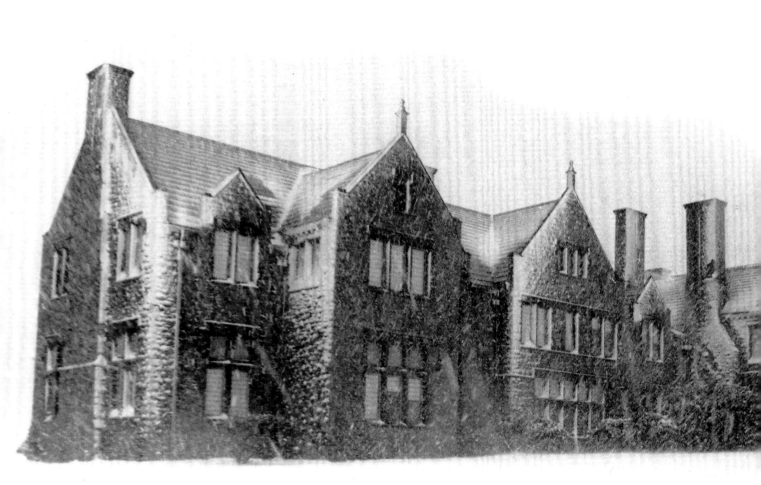

Foreword

For more than a century Rough Point kept its secrets. Secluded behind a granite wall on one side and imposing cliffs on the other, the house remained a mystery to local citizens and visitors to Newport, and the gates were never open to them until 1999. Since then, Doris Duke's Rough Point has revealed the remarkable legacy of the Duke family on the magnificent site that Frederick Vanderbilt first envisioned in 1887.

Rough Point stands out amongst historic houses. Its location on the ocean is simultaneously dramatic and refined, a spectacular setting in a city that is renowned for its vistas. But what lies outside is surpassed by what is found within. The collection assembled by the Dukes sits undisturbed and as it was when Doris Duke last left the house in 1992. Few houses can make equal claims, and fewer yet can claim such distinguished collections. Canvases by Gainsborough, Van Dyck, and Renoir populate the house, at home amongst furniture and other decorative arts of equal caliber.

Miss Duke's legacy is remarkable. During her life she restored a sizable portion of the 18th-century houses in Newport by founding the Newport Restoration Foundation in 1968. At her death, not only did she leave Rough Point, but two other of her residences, Duke Farms in Hillsborough, New Jersey, and Shangri La in Honolulu, for public, educational uses. The Doris Duke Charitable Foundation, created by her will, continues to do enormous good by funding programs that address vital public needs.

The Newport Restoration Foundation is pleased to invite you, through these pages, to tour Rough Point and enjoy its charms, as did the families who lived here over the years.

Pieter N. Roos
Executive Director
Newport Restoration Foundation

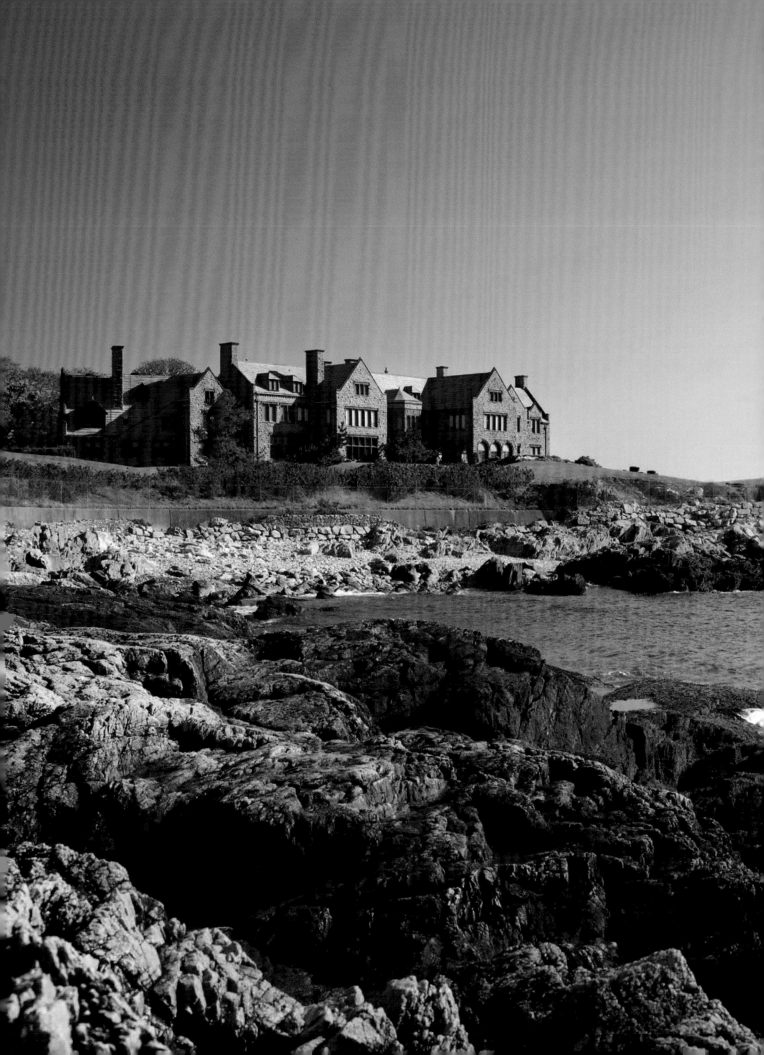

Contents

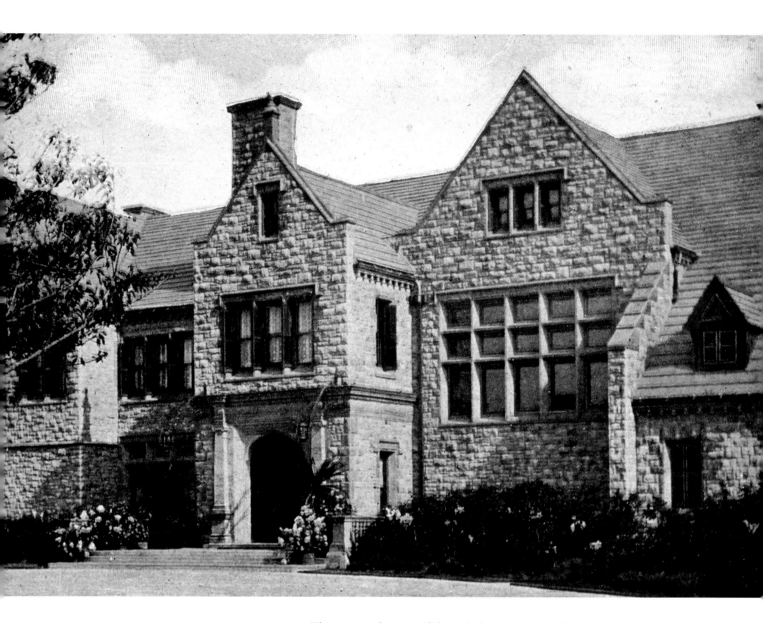

This postcard is one of the only known views of Rough Point's front façade during the Vanderbilt era. Because of the seamless nature of the later additions, at first glance it may not appear to have changed much in the last hundred years, but more careful examination soon reveals how much smaller the house was originally, and that the main stair was substantially different from its current configuration. The gable-end to the right of the front door was expanded forward, so that it approximately parallels the door. One of the minor architectural mysteries of the house is the question of its portico. Most houses of this size and style proudly displayed this bit of architectural formality, and Rough Point's entrance seems ripe for one, but there is no evidence that a portico was ever designed — and it was certainly never built.

Architecture

In 1887, Frederick Vanderbilt commissioned the largest house that the Newport summer colony had yet seen. It was the latest local monument to Gilded Age wealth, constructed solidly in granite and sandstone and placed in a beautiful and dramatic setting. For an appropriate name, Vanderbilt took an old moniker for the obscure water-washed promontory that bordered the property. For just a bit more than a century, Rough Point served as the home of three families whose taste never wavered from the romantic vision of a summer home that married the sea, the rugged coastline, and the house.

Frederick and Louise Vanderbilt vacationed in Newport for some years in rented properties before they committed to buying land and building their own house. Their efforts started with the purchase in 1887 of a wood-frame house and land belonging to William W. Tucker, but what Frederick acquired was only the first half of the property known today as Rough Point. It was not until the following year that he managed to acquire an adjacent second home and parcel belonging to Jacob Dunnell, and combined them to form one of the finest properties in southern Newport. The corner plot of nearly ten acres overlooks Easton's Beach and Middletown in one direction and the Atlantic in the other, and frames them both with the rugged beauty of the rocky coastline. Frederick, a younger brother of the Vanderbilts who built the Breakers and Marble House, was the first of the three to build a new house. The design was more conservative than his older brothers' grand palaces, and today recalls a style of local summer housing that, although large, was less ostentatious than what followed.

Vanderbilt's choice of the architecture firm of Peabody & Stearns has had the most lasting effect since every subsequent architect's alterations to Rough Point closely followed the style of the original design. The firm, well known in its own time, is still recognized for its contributions to New England's architecture at the turn of the 20th century. Locally, the architects designed a number of houses for Newport's summer colonists, among them Vinland and the original Breakers, which belonged to Frederick's sister and brother respectively.

Rough Point was designed in what has been best described as English manorial style, the intent being to evoke the feel of an English country house. In reality, Peabody & Stearn's design is an interpretation of different English styles of the 16th and 17th centuries; the result is not English at all, but unmistakably American. Where the original English country house is a form that usually was added to haphazardly over the centuries, Rough Point is a well organized and carefully conceived design — modern for its day and replete with the latest services and efficiencies of the 1890s.

Frederick Vanderbilt

It is not Rough Point but at first glance the two houses might be mistaken for each other. Peabody & Stearns, the architects for Rough Point, designed many houses for the summer residents of Newport. Among them was this one, the original Breakers. It was designed by Robert Swain Peabody for tobacco magnate Pierre Lorillard, and was completed in 1878. Although they were very different houses in their detailing, the massing of Rough Point and the Breakers were quite similar. Each house also made extensive use of carved wooden ornamentation and tracery. The firm was responsible for designing more than a dozen private homes in Newport, and they all bore some design similarity to one another. The original Breakers was purchased by Cornelius Vanderbilt II (Frederick's eldest brother) in 1885 and was much beloved by the Vanderbilt family. Unfortunately, it burned to the ground during a brief but spectacular fire in November of 1892, and was quickly replaced by the current Breakers, which remains the largest house in Newport.

The Vanderbilts' tenure at Rough Point was followed by the brief ownership of William and Nancy Leeds, who purchased the house seventeen years after it was built. Perhaps because it was relatively new, they made no substantial changes. Although they hired John Russell Pope to make some alterations, the work was cosmetic in nature, and this well-known architect seems to have made little lasting impression on the building. What changes he made appear to have been erased during later reconstructions.

When the Duke family purchased Rough Point in 1922, it was then thirty-one years after its initial construction and styles had changed. The house did not meet their needs either in size or floor plan, and they hired Horace Trumbauer to make suitable modifications. The Dukes' connection with Trumbauer was an old one. Their New York house was one of his earlier projects, and they had also commissioned him to design the original quadrangle for the new Duke University and a palatial house that was never completed at their New Jersey estate. Outside of his work for the Dukes, Trumbauer's firm was very active in Newport, and several houses from his drawing board still survive, including Clarendon Court, Miramar, and The Elms.

It was Trumbauer who had the greatest lasting effect on the interior of the house. Under his direction and with the firm of White Allom as interior decorator, the floor plan and aesthetics of the house changed substantially. Most of the wooden floors and much of the dark oak tracery and paneling popular during the Victorian era gave way to marble floors and molded plaster ceilings that provided a lighter look more in keeping with the decor of the 1920s. The dining room and the stairway were enlarged, and a new drawing room and the spacious Music Room were added. Several new guest rooms were installed above the music room, and this new wing extended the northeast end of the house by sixty feet. On the exterior, Trumbauer used materials identical to the original construction. Only careful examination reveals where the original ends and the new work begins. Although she lived here longer than anyone else, Doris Duke never changed the substance of her parents' alterations. She enjoyed furnishing and decorating the house, which had been left empty by her mother. She refined the decoration and details throughout her life, but regarded the structure itself as a finished work.

Rough Point was occupied as a part-time residence for one hundred and four years, which in terms of Newport's lengthy history may not seem a lot, but is in fact a longer period than for many of the largest houses in Newport. The original design resonated with every owner and every architect, and throughout its history they carefully preserved this American vision of an English manor by the seaside.

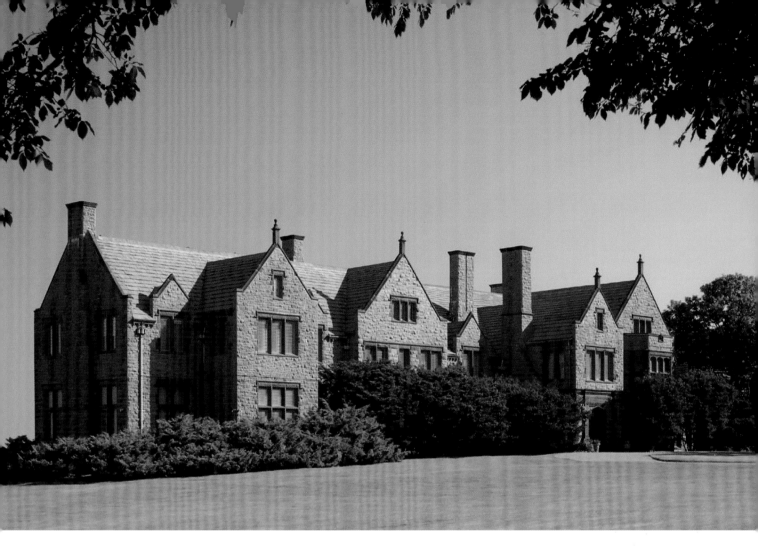

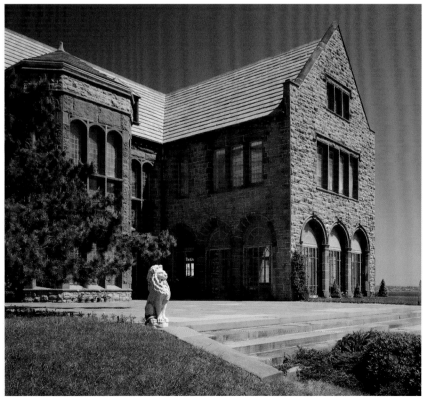

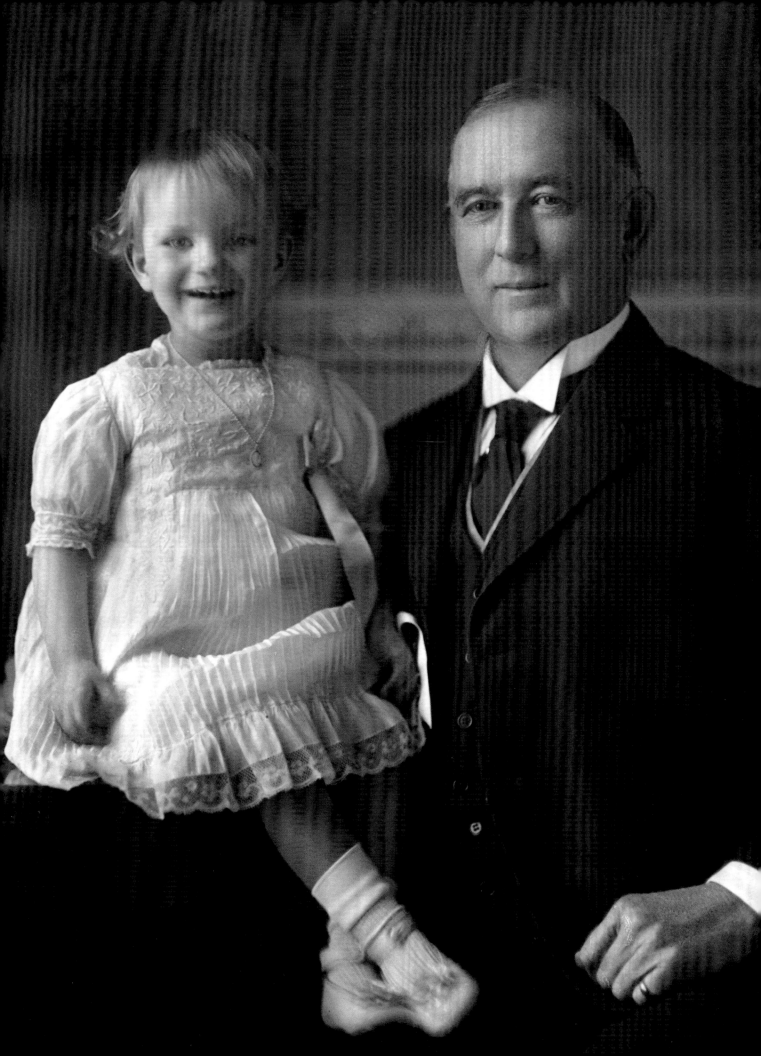

Families of Rough Point

For more than one hundred years Rough Point was a very private residence situated in one of the most beautiful locations in Rhode Island. Aside from its staff and its guests, only three families have enjoyed strolling on its rolling lawn and waking up to its surf and sunrises. Frederick and Louise Vanderbilt were not only the first of these families, but also its creators, whose vision still dominates the landscape. The Leeds and the Dukes followed them, but it was Rough Point's last resident, Doris Duke, who gave the house the character for which it will always be known.

Frederick Vanderbilt was the sixth child of William Henry Vanderbilt and the grandson of Cornelius Vanderbilt, who had founded the family fortune. Always a loyal participant in the family business, Frederick grew up as a younger son in a financial empire that passed its money and power to elder sons. It seems to have suited the retiring Frederick to remain a smaller part of the larger Vanderbilt dynasty. Nonetheless, the Vanderbilts were synonymous with grand architecture, and Frederick constructed no fewer than three great houses by the time he died. Besides Rough Point, there was a town house in New York and the house that he cherished the most, his estate in Hyde Park, New York. It was there that he retired to beautiful views of the Hudson Valley and his beloved library. As an inheritor of great wealth, he was one of a very select group of heirs who was careful and clever enough to die with more money than he inherited. His quiet lifestyle, as well as a lack of children, did not require the lavish spending of his siblings and may well have been a reason that he did not relish Newport with the same intensity as his siblings. Although he enjoyed Rough Point and participated in its construction, he only spent a few years there before renting it out and eventually selling it.

William Leeds, known as the "tinplate king," was at the height of his wealth in 1906, and his wife Nancy desired a house in Newport to complete her social aspirations. When the Vanderbilts offered Rough Point for sale, they purchased it promptly. The Leeds's ambitions were not to be realized, however, as Mr. Leeds suffered a series of strokes that resulted in his death in 1908. For the next dozen years, Mrs. Leeds spent less time in the house, and more and more time in Europe, eventually marrying Prince Christopher of Greece. In 1922, needing money, she sold the house to James Duke, thus launching Rough Point's most illustrious era, under the Duke family's ownership.

This photograph of Doris Duke and her mother Nanaline is believed to have been taken on a family trip to France in 1923.

(Left) James B. Duke and Doris ca. 1914

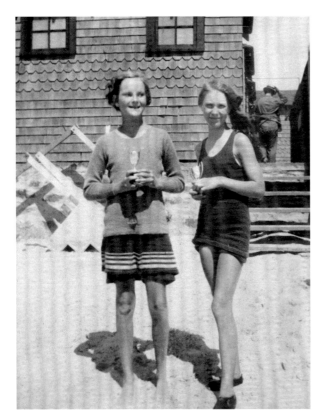

One of Doris Duke's steadfast childhood friends was Alletta Morris whose family also had a house in Newport. Alletta's childhood diary is in the possession of the Preservation Society of Newport County and provides not only an invaluable record of the children's activities during the 1920s, but also the only known insight into Doris Duke's day-to-day activities at a young age. They were close, and the diary is peppered with references to "DD." The photograph above shows the two girls with their trophies for a "Sand Modeling Contest" at Bailey's Beach in 1924. The small, silver trophy that Doris won is in the collections at Rough Point along with a number of others for tennis, dancing, and similar activities.

In the late-19th century, James Buchanan "Buck" Duke took his father's successful tobacco business and built it into one of the first national monopolies, and created for his family one of the largest fortunes of its day. In the process, he moved from North Carolina to New York and married an eligible Atlanta widow named Nanaline Holt Inman. Their only child, Doris, was born in 1912. Nanaline was enamored of Newport, and in 1915 the Dukes started vacationing there, renting a succession of houses before finally purchasing Rough Point. The Dukes' renovations at Rough Point were complete in 1924, but the family had little time to enjoy them, for Buck Duke died in 1925. Doris Duke was devoted to her father, and his death was a major blow to her at the age of twelve. It was a loss that affected her for the rest of her life.

Throughout her teenage years, Doris Duke spent her summers at Rough Point, but in 1935 Doris married James Cromwell, and then, for almost twenty-five years, Newport was only a tangential part of her life. Nanaline continued her summers at Rough Point through 1938, but in September of that year one of the worst hurricanes in New England's history devastated Rhode Island. Rough Point was not spared, with winds and flooding that tore apart the landscape, although the house remained largely undamaged. This event and World War II soon after, curtailed Mrs. Duke's visits. After the war, advancing age tended to keep her time at the house brief and infrequent, and by the early fifties the house was empty, but for its few caretakers.

Doris Duke, now in her forties, was at first unsure what to do with her Newport house. Many of Newport's large summer houses were more or less abandoned, ghostly relics of another age. An offer by Miss Duke to donate Rough Point to Newport Hospital met with little interest, and the fate of the property hung in the balance. By the late 1950s, her thinking had changed, and it is clear that her enthusiasm for the house was growing. Oral histories of the house from that period indicate that it was completely empty, but in 1958 and 1959 she started bringing in many family pieces and purchasing art and antiques to fill it. In 1960, the house was open again, and over the years it became one of her favorites. By the end of her life, she spent as much time here as she did in any other of her residences. Her last visit was in 1992, for the following year she became increasingly debilitated from severe arthritis and a series of strokes. She died in her Beverly Hills home in October of 1993.

Once so private, Rough Point now shares its wonders with the rest of us, but the house is more than just objects and scenery. It fascinates because it reveals the character of its owners in the work and the creativity that they wrought on it, and it is through their choices that this house remains so vibrant today.

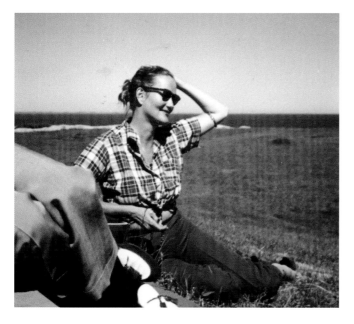

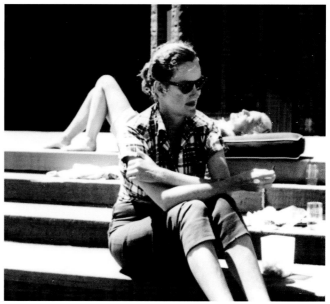

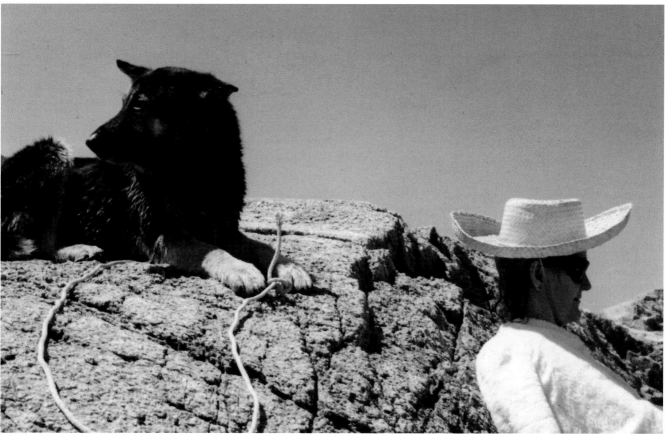

Doris Duke went occasionally to Rough Point in the late-1950s at a time when the house was little used. The two photos (top) are from a series in her personal collections that documented a trip to Rough Point for what appears to have been a picnic on the lawn and terrace. In the background on the right, her lifelong friend Alletta Morris McBean may be seen relaxing in the sun. Other photos in the group seem to indicate that the house was shuttered and mothballed. (Above) Miss Duke and one of her favorite dogs relax on the rocks at the ocean's edge.

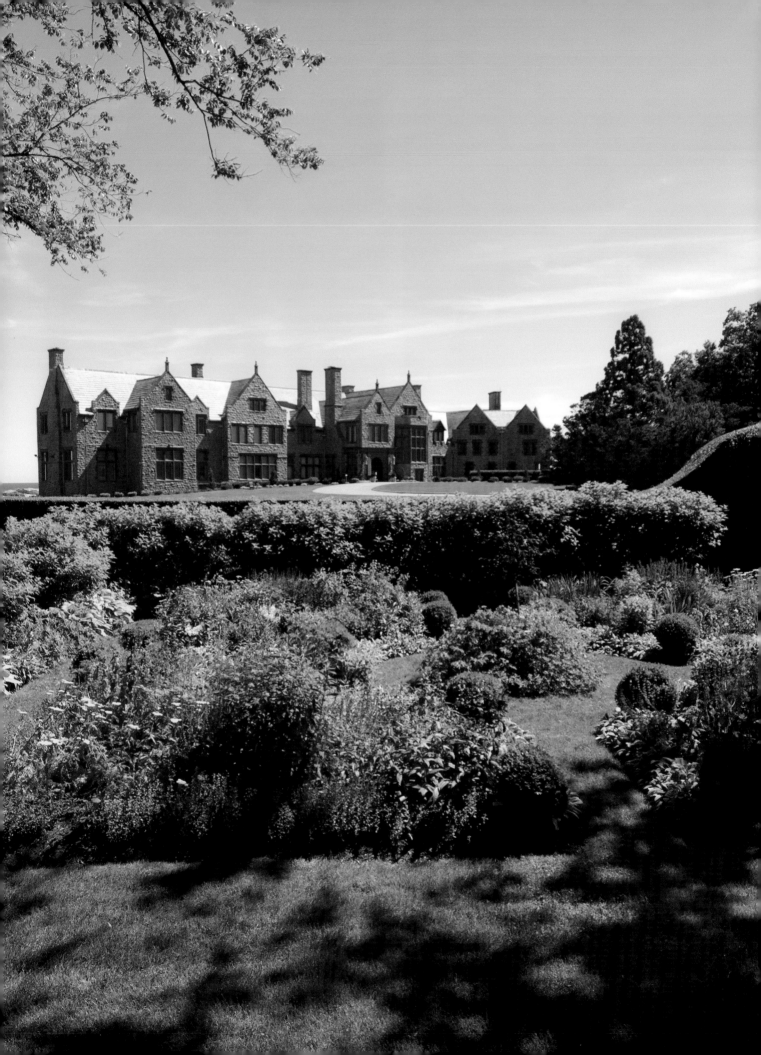

Landscape

In 1887 upon the recommendation of his friend, Seward Webb, Frederick Vanderbilt hired Frederick Law Olmsted to design the new grounds at Rough Point. The Boston-based landscape architect was well known by 1887. His designs for New York's Central Park, the Boston Park System, and numerous Newport summer cottages, spoke for themselves. His vision of the American landscape and its practical interpretation set seminal trends in the 19th century that are still influential today. Despite the obvious attraction of an Olmsted landscape for Vanderbilt's new property, the cost for implementing the original plan was too high and the features too ambitious for the relatively small size of the property, so the project was scaled down several times. Initially, the landscape was to include barns, stables and other outbuildings, and even an outdoor bowling alley, set amidst a landscape designed in the style of an English park. In the final draft, Olmsted created a vision that highlighted the rugged beauty of the site with its remarkable ocean vistas.

The work progressed, and by 1889, more than 34,000 plants were ordered and installed at Rough Point. The site was overplanted to be sure, but with the knowledge that many plants would be lost under the harsh conditions of a landscape by the sea, and those that remained would serve as a windbreak and support for each other. In the first season, as a temporary measure, fast-growing squash plants were grown over large expanses of ground to hide the freshly turned earth resulting from the re-grading, leading local wags to dub the new estate "Pumpkin Lawn" in its early years.

By 1891, the house and grounds were complete. Rough Point was described by critics as "an attractive mixture of luxury and rustic simplicity," giving the impression of a "picturesque manor house of the English shires." Sweeping lawns accentuated the rough terrain, while thickly planted shrubberies screened the property from its neighbors and deepened its spacious quality. Throughout the property, views to the water were shaped and accentuated by carefully placed specimen trees or small groves.

After the Leeds family bought Rough Point in 1906, Mr. Leeds enjoyed the property for just two years before his death. Subsequently his wife used Rough Point only infrequently, and often rented the property to others, so little attention was paid to the grounds. In 1922, after thirty years of irregular care, only the hardiest of Olmsted's plants survived.

When the Dukes purchased the estate, they brought with them considerable experience in shaping landscapes. Gardeners from Mr. Duke's vast New Jersey estate, Duke Farms, came to Newport to oversee improvements. The terraces were redesigned, and the extensive shrubberies along Bellevue Avenue were thickened to increase privacy. The driveway turnaround, which had been laid out in a teardrop design by Olmsted, was enlarged into a broad circle to compliment the enlarged scale of the house.

Frederick Law Olmsted defined landscape architecture in the United States during the late-19th century. Noted for many important and monumental works, including Central Park in New York City and the "Emerald Ring" of parks in Boston, Olmsted was also responsible for the landscaping of many private Newport homes, including Rough Point.

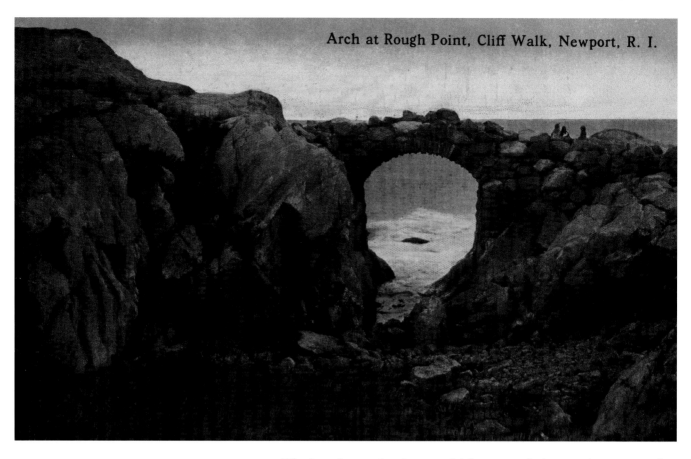

Arch at Rough Point, Cliff Walk, Newport, R. I.

The broad sweeping lawns, which captured views to the water and the rocky shoreline, remained an integral part of Rough Point's landscape, as they still do today. Privet hedges were planted to protect a large cut-flower garden and a vegetable garden from the fierce ocean winds. These gardens were located far from the main house, and even today function as separate and distinct garden "rooms," which are not connected in any way to the views or setting of the main house.

One of the most profound landscaping events in local history transformed Rough Point and all of Newport when a powerful hurricane tore apart decades of careful work in September of 1938. In the following years, Mrs. Duke's time in Newport diminished, and Rough Point saw little more than routine maintenance by the 1950s. Even so, during this period, the sides of the ravine were planted heavily with rock garden plants, and low shrubs and rugosa rose hedges edged the lawns and softened the look of the wire fence that was installed to discourage intrusions from the Cliff Walk.

One of the site's most notable original features was a stone bridge that arched across the ravine on the ocean side of the house. It solved Vanderbilt's problem of what to do with the heavy foot-traffic on the Cliff Walk every summer, and at the same time provided a picturesque icon for the house itself. Indeed, early photographs of the house almost always feature the house and the bridge together. The sculptural quality of the bridge was ever-changing as the tide rose and fell in the ravine, the surf sometimes ferocious and at other times almost flat. At the 1891 housewarming, the bridge and the chasm were artfully illuminated, a

celebration of the "rustic simplicity" of the landscape design. Sadly, the original bridge was swept away in the 1938 hurricane and was replaced for decades with a succession of wooden bridges. The current bridge of steel and stone was constructed in 2006. The rocks forming the ravine comprise the actual geographical feature known as Rough Point, a name that predates the house by at least a hundred years and may go back as far as the 18th century. The larger rock formation to the south, often mistakenly referred to as Rough Point, is actually named Midship Rock.

When Doris Duke took up residence in the house, the landscaping was refreshed, although she chose not to make major changes, leaving the property largely as it appears today. Many remnants of the original Olmsted plan are still in evidence. The large oak, which frames the view to the water at the main entrance, may predate the Vanderbilts, and the thick belt of low plantings near the front wall is also original. In the 1960s, Miss Duke added rhododendron, lilacs, dogwoods, yews, and junipers. The yews along the front of the main house were pruned carefully to appear as picturesque and windswept as the site itself. The failing old yews were replaced in 2013.

Flowers for the cutting garden were started from seed in the greenhouses at Duke Farms. They were transported to Newport in mid-May and set out in the geometric beds of the garden. Snapdragons, begonias, geraniums, dahlias, marigolds, petunias, cosmos, and gladiolas were some of Miss Duke's favorites. Beds of iris, lilies, and roses remained from earlier days. Sheltered from the wind, the long row of peach trees produced fruit every summer. These trees provided both a practical and decorative accent to the garden.

The grounds of Rough Point have been maintained by Duke family gardeners since 1922, and by the NRF crew since 1999, and their work has always taken the form of an epic campaign. The qualities that make Rough Point so picturesque, often spell trouble for its staff. The site is rough and rocky, with thin soils, barely enough to keep its grass green in the heat of summer. Throughout the 20th century, numerous hurricanes and merciless winter weather battered and beat this rocky peninsula, making spring replanting a major annual task. But despite its gardeners' best efforts to tame the grounds, ultimately the rustic simplicity, first established by Olmsted and Vanderbilt, has remained the true spirit behind Rough Point's landscape.

This document from the Olmsted archives illustrates the extensive plan by Olmsted for the new plantings in 1889. Detailed instructions, along with the design plan, enabled the gardeners to follow the architect's plan precisely.

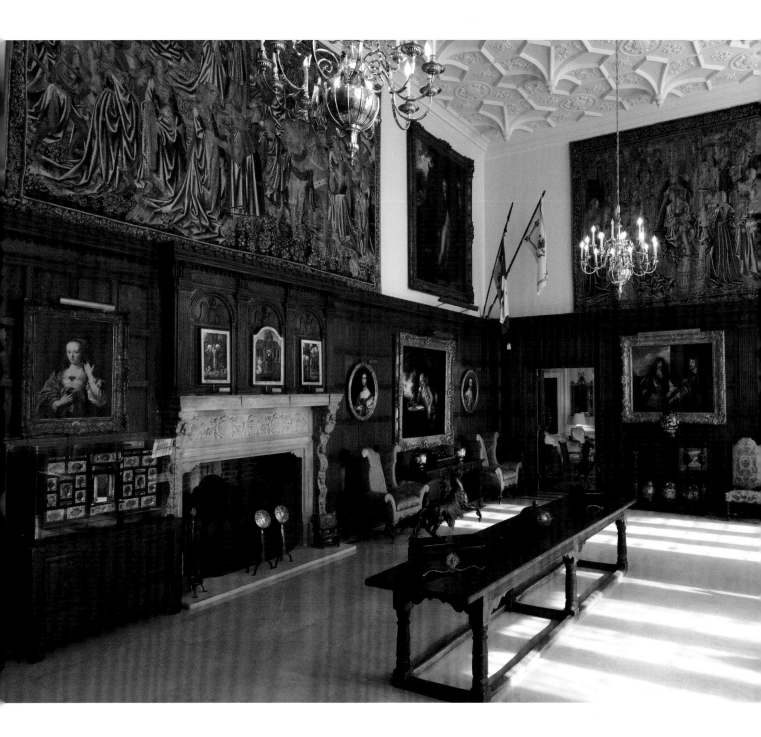

Great Hall

The Great Hall is one of the many areas of the house that architect Horace Trumbauer changed dramatically for James and Nanaline Duke. In its original configuration, the room had approximately the same square footage, but part of the ceiling reached all the way to the rafters — about fifteen feet higher than the current ceiling height. Also, the Hall featured more architectural details, such as small balconies and oriel windows, to give it the feeling of a palatial courtyard. Even Mrs. Vanderbilt's bedroom had a diminutive balcony overlooking the Hall, and the third floor rooms at either end were separated by the large space in the center and were reached by separate stairways from the east and west ends of the second floor.

The Dukes clearly wanted their home at Rough Point to serve as much as a display space for their fine art collection as an architectural tour de force. The ceiling in the Great Hall is now at the second-floor level throughout, and the molded plaster detail is likely from the Trumbauer renovation. At twenty-six feet, the height of the ceiling is inspiring. The Dukes installed the bright marble floor in this room, which had been originally built with dark oak floors to match the woodwork. The doors and paneling are remnants of the Vanderbilts' design, but the overall amount of oak and some of the detailing were changed with Trumbauer's reinterpretation of the space. The fine art on view includes some of the best pieces in the collection, befitting such a grand architectural setting.

The set of three tapestries is the best group in the house, and probably each retains its original size and borders. Made in about 1510, the tapestries illustrate contemporary courtly life, including a courting scene, a betrothal scene in the large central panel, and a coronation scene. The coronation is thought to be that of Louis XII, a French monarch of the period who was much beloved by his people.

Many of the paintings in Rough Point were created by artists who painted for the royal court. First in the Great Hall is *Gentleman in a Red Coat*, by Sir Henry Raeburn (1756-1823), an 18th-century limner to royalty in Scotland. Although the gentleman is unidentified, his clothing and noble bearing help to convey his importance in contemporary society. The exquisitely charming *Lady in Pearls* (purchased by Miss

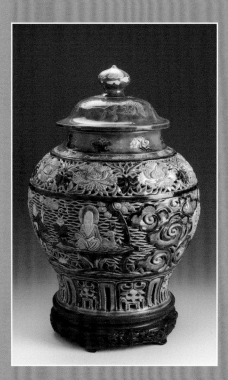

The Ming Dynasty in China was the dawn of a new era in porcelain decoration. A new technique known as Fahua utilized the placement of tiny threads of clay on the surface of a piece to prevent the different glazes from sagging and blending together in the kiln. The revolutionary technique meant that intricate shapes could be successfully executed with glaze colors. The central piece in the Great Hall is a wine jar that is also pierced in its outer shell, greatly increasing the difficulty of finishing the piece without allowing it to collapse. Fittingly, the subject of the decoration is the mythical wise Immortals, surrounded by symbols of their intelligence and longevity.

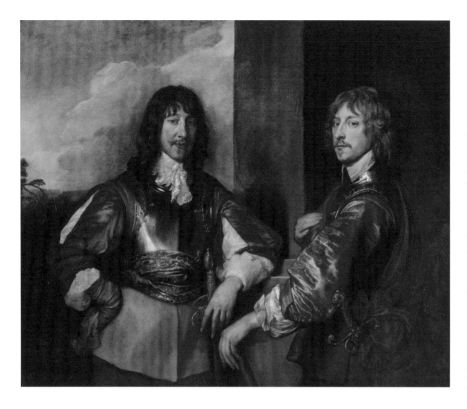

*Sir Anthony van Dyck's double portrait,
The Earl of Newport and Lord Goring,
is not only one of the masterpieces of
the Rough Point collection, but it also
represents an intriguing story of the
English Civil War. The two noblemen
were the closest of friends and held high
offices on the Royalist side during the
conflict. However, Goring vacillated in
his allegiance and was subsequently
mistrusted by both sides. Following the
war, van Dyck painted two versions of
the painting for the two friends. Despite
Goring's calm appearance in the paint-
ing, he was soon forced to flee to France,
then Spain. This painting was his copy
and eventually made its way from Spain
to a sale in America in the 20th century.*

Duke at Parke-Bernet Galleries in 1971) was painted by Ferdinand Bol (1616-1680), a colleague of Rembrandt's in Amsterdam during the 17th century who developed his own elegant style. The portrait of this young beauty reflects some of Rembrandt's style and quiet expression of elegance. Two large portraits by Thomas Gainsborough (1727-1788) show the accomplished and graceful style of the most versatile English painter of the 18th century. His portraits of Lord Peter Burrell and Raphael Franco were added to the collection by James Duke, who purchased them from Duveen Brothers in New York. Both portraits convey something of the character of the subjects, while the backgrounds are idealized landscapes; Burrell's background is a pleasant and peaceful woodland, in contrast to Franco's London landscape, with the prominent dome of St. Paul's Cathedral anchoring the scene.

An assembled pair of portraits in the Hall are Charles I, in the style of Jan Mijtens (1614-1670), and his queen, Henrietta Maria, in the style of John Michael Wright (1617-1694). These pictures were placed in similar frames many decades ago to form a pleasing 17th-century couple and the appearance of a matched pair of portraits. The queen's portrait is similar to one painted by Sir Anthony van Dyck (1599-1641). The artist was one of the most important and prolific portraitists of the 17th century, who spent two years early in his career in the studio of Peter Paul Rubens. In 1632 he came to London as the chief court painter to King Charles I.

A gem from the 17th century is the double portrait by van Dyck, depicting the Earl of Newport and his good friend, Lord Goring. The Earl of Newport and Lord Goring were fellow soldiers and leaders during the English Civil War, though it was discovered that Goring was accepting funds from both sides in the conflict, resulting in his eventual flight to Europe. Two diminutive but finely detailed art works are the portraits of the Duke d'Alençon and Diane de Poitiers, from the studio of the French royal court painter, François Clouet (1515-1572). Clouet served four French kings, and his studio produced highly detailed portraits such as these, along with genre scenes and even decorations for funeral ceremonies and the triumphal entries of the French kings.

Chinese porcelains comprise a second category of art works in the Great Hall, and Doris Duke assembled some rare examples of these.

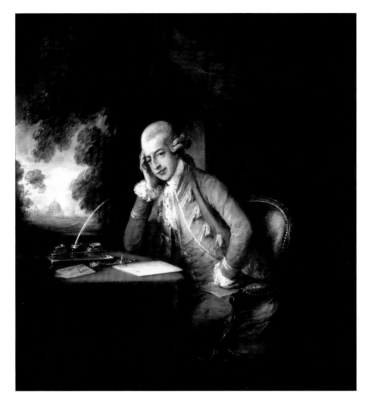

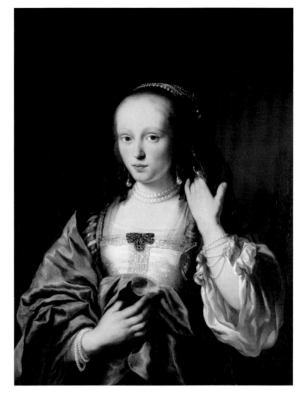

There are three garden seats and three wine jars, all in the style of the Ming Dynasty of about 1475. Although only a few glaze colors were used by these Ming artisans, the style and beauty of these pieces is striking and was made possible by an innovative contemporary process known as Fahua, which kept the glazes from running together during firing.

The prize among the porcelain pieces in the Great Hall is a highly decorated wine jar that incorporated yet another process utilized before the initial firing. After the vessel was formed by the artist and dried to the stage at which it could support itself, hundreds of small bits of the background were cut away, leaving a pierced outer shell for the jar, resulting in a light and elegant appearance. As many as seventy separate steps might be involved in the production of this style of porcelain. The design itself consists of purely decorative bands at the top and bottom, and in the middle, scenes of the Immortals paying homage to Shou-Lao, the god of longevity. The god is surrounded by symbols of long life, including flying cranes and a crawling tortoise.

The premier bronze in the Great Hall is *The Infant Jesus* by Flemish sculptor François Du Quesnoy (1597-1643). In the period 1625-1630, the artist explored the motifs of figures of young children, including cupids, satyrs, and bacchantes, as well as the infant Christ, such as the one at Rough Point. These pieces were some of his most famous and influential sculptures. This figure of the sleeping child is reminiscent of decorations found on ancient sarcophagi, which the artist studied during a residence of several years in Italy.

(Left) Portrait of Raphael Franco, by Thomas Gainsborough, shows off the artist's most elegant style. This portrait of the preoccupied Portuguese jewel merchant in his London office was painted in the same year as the artist's famous portraits of George III and his queen, Charlotte of Mecklenburg.

(Right) The unidentified young beauty in the blue shawl is a favorite among visitors to Rough Point, and the painting is a gem of late Renaissance portraiture from Holland. The artist, Ferdinand Bol (1616-1680), was a student in Rembrandt's studio in Amsterdam before becoming one of the city's leading painters. He developed his own style, combining Rembrandt's quiet expression of character with greater color and elegance. Lady in Pearls is a figure in peaceful repose and a superb example of the subtle variations in light and shadow that characterized this period of Dutch painting. Especially well executed and preserved without substantial alteration, this painting is one of the finest in the house.

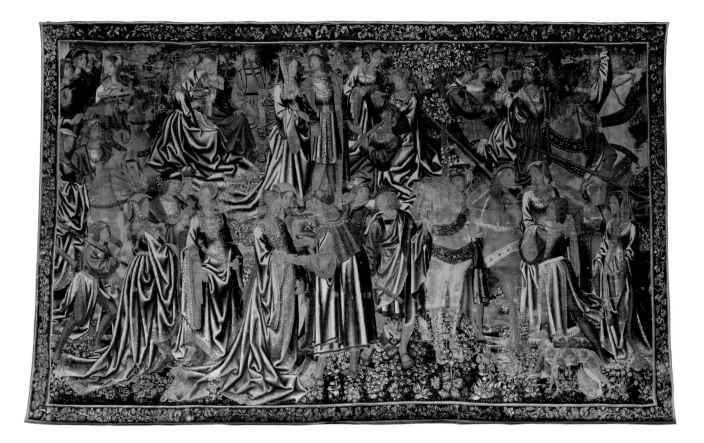

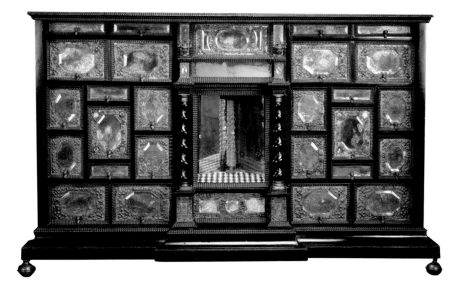

(Above) Courting Scene, Brussels, Gothic tapestry; silk and wool, circa 1510. This central panel in a group of three richly illustrates the contemporary social life of royalty and nobility.

(Right) Table chest, unknown maker, Spain; ebony and secondary woods, brass, glass, and semiprecious brilliants, circa 17th century. This highly decorated storage piece includes a playful trompe l'oeil receding chamber in the center and richly detailed trim.

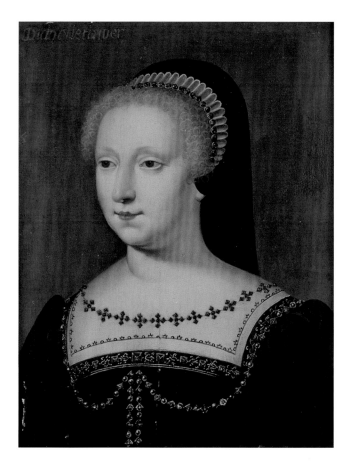

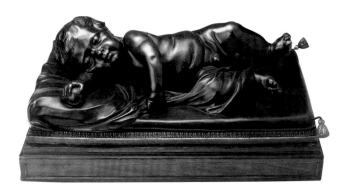

(Above) Portrait of Diane de Poitiers and Portrait of the Duke d'Alençon, studio of François Clouet (1515-1572), oil on panel. The artist's studio produced numerous copies of his portraits of royal and noble luminaries for purchase by their admirers.

(Left) Infant Jesus, François Duquesnoy (1597-1643), southern Netherlands; bronze, circa 1630. The artist sculpted many tender and sensual statuettes and reliefs, in both marble and bronze.

Yellow Room

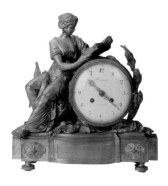

The Yellow Room is a striking contrast to the Great Hall and the other central rooms, which are similar in feeling, with marble or dark wood floors, stone and dark oak trim, and high ceilings. Entering the Yellow Room is like looking at a page in a decoration pattern book of the late 19th century. The classical design elements of this room were in vogue in the 1920s and were published in various books, not least of which was *The Decoration of Houses* by Edith Wharton and Ogden Codman. The design by White Allom that created this room makes it one of the prettiest in the house and one whose elegant beauty never fails to elicit praise from visitors. The height of the ceiling is attenuated by the presence of a large rock-crystal chandelier and the white classical trim, all of which stand out against the yellow walls. Straight across the room is a George III fireplace, done in contrasting dark red and white marble. Although the floor is dark, it is a *parquet de Versailles* in French oak of 18th-century vintage, and a great find that was typical of Doris Duke's collecting.

Miss Duke's housekeepers remember that the Yellow Room received but little use, serving mostly as a stylishly adorned passage to the Music Room and the Solarium. Miss Duke found the furnishings and garnitures piece by piece to create a complete and personal assemblage of the finest quality.

Adorning the mantel is a group of objects carefully chosen for their aesthetic design and subtle, elegant colors. At the center is a clock made in Paris about 1775, in the Louis XVI style; a figure of Wisdom sits astride the drum-shaped case that holds the clockworks, all done in gilt bronze. On each side of the clock are Louis XVI urn-shaped scent vessels of carved alabaster and gilt bronze. The top of each container can be turned upside-down to expose a small amount of scent, which wafted through the air. At the ends of the mantel are a pair of Paris jardinières of about 1810, decorated with bands of gilt and painted with scenes of cupids and nymphs in black and tones of gray.

At the west side of the room are groupings of remarkable objects: two pairs of mirrored doors and a pair of unusual Russian tables. The giltwood and glass doors were made in Genoa during the 18th century and originally graced one of the city's fine palaces. The architect Stanford White purchased and imported them for the William Whitney mansion in New York. They were not used in that project and remained in White's warehouse until after his death, when they were sold. Doris

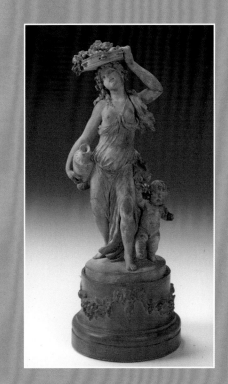

(Left) Louis XVI-style mantel clock by an unknown maker, Paris, France, circa 1775; steel, bronze, ormolu.

A small and incidental piece in the artfully contrived Yellow Room, the terracotta sculpture, Nymph and Child, *is an intimate and dynamic work of art. Attributed to the French sculptor known as Clodion (Claude Michel, 1738-1814), this group is typical of his work that often featured nymphs, satyrs, bacchantes, and other classical figures, sensually portrayed. While his earlier figures were often shown in energetic, whirling motion, later pieces such as this one, reflect long, flowing lines and a restrained tone. Executed in great detail, the nymph carries a pitcher, with a basket of fruit on her head, while the child at her side holds a staff draped with clusters of grapes.*

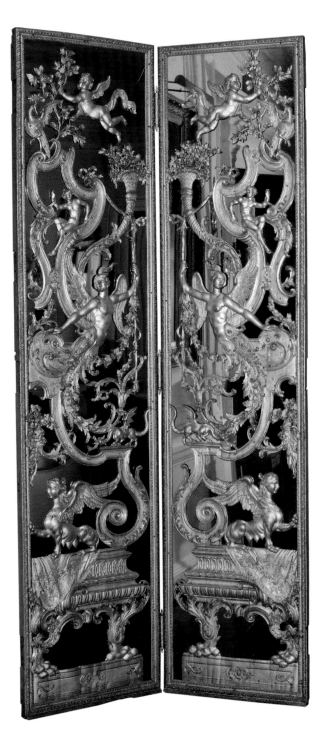

Giltwood and glass door panels, designed by Lorenzo da Ferrari (1686-1744), Genoa, Italy; wood, mirrored glass, and gold leaf. These ornate doors are in the Rococo style, each with a sphinx and classical figures among scrolling strapwork and foliate borders.

Duke bought the four panels in an auction at the Bois Doré estate auction in Newport in 1977. Four matching doors reside at the Metropolitan Museum of Art in New York City. The tables were made of ivory and silver in the late-18th century and are the only Russian pieces in the house. The two tables are slightly different in decoration — the top corners of one inlaid with rosettes and the second inlaid with the monogram of Catherine the Great. Doris Duke purchased these during her residence in Paris.

Perhaps the most astonishing pieces in the Yellow Room are the suite of Louis XVI chairs and sofa, made in the mid-18th century. Some of the chairs are stamped "Falconet" (Louis Falconet, active circa 1710-1775), and the sofa is stamped "N.Q. Foliot" (Nicolas-Quinibert Foliot, 1706-1776). Originally used in the Château de Valency, this group was bought by Doris Duke in 1960, while she was still in the initial stages of redecorating Rough Point. The elaborately carved areas retain their original green paint and gold leaf, but even more extraordinary is the contemporary embroidered silk upholstery. The fabric is so fragile that it also provides evidence that this room was never used, but meant to be seen as a delightful image of artistry and decoration. The central carpet is also French, an Aubusson of the late-18th century, with griffins, urns, and cameos with floral garlands.

Complementing the furnishings, which are mostly French, are several English portraits, continuing the trend of English portraiture found throughout the house. Over the mantel is the striking *Portrait of Lady Fitzroy* by John Hoppner, probably painted not long before her death in 1797. On the west wall of the room hangs another Hoppner, the *Portriat of Lady St. John*, also displaying all the expertise of the foremost English portraitist of his time. Also on the west wall is the *Portrait of Thomas Edward Freeman*, painted in the late-18th century by Prince Hoare (1755-1834), an English painter and playwright. On the south wall is a portrait of an unidentified lady, done in the style of Gainsborough, and the Portrait of Master Thomas Barber, painted about 1800 by another royal painter, Sir Thomas Lawrence (1769-1830). Lawrence followed Van Dyck, Gainsborough, Reynolds, and Hoppner — all represented in the Rough Point collection — as the preeminent portrait painter in Britain.

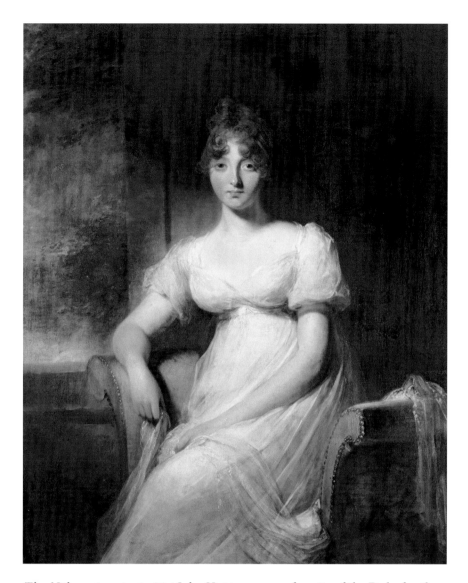

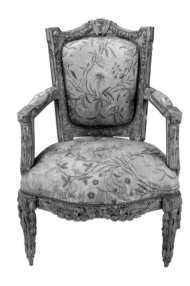

Louis XVI period open armchair by Louis Falconet, France; wood, silk, paint, and gold leaf. Part of a set with three other chairs and a sofa, this piece exemplifies Doris Duke's collector's eye for rare furnishings and textiles.

The 18th-century portraitist John Hoppner was a favorite of the Duke family. Like most of the artists represented in the collection, he was a painter at the royal court and a master portraitist of his time. Portrait of Lady St. John shows the master's hand in his delicate and glowing rendition of the lady's face and hair, the fine fabric of her gown, and the elegance of the setting. The Rough Point collection includes a number of other works by Hoppner.

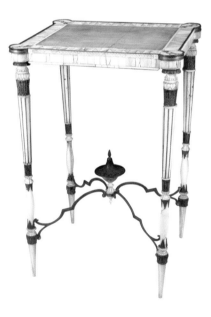

(Right) Neoclassical-style occasional table by an unknown maker, Russia; ivory, wood and silver, circa 1790. The table would have originally appeared with some ivory inlay dyed blue, and with sparkling silver, but the years have diminished its glow. Still, it befits the royal monogram of Catherine the Great, inlaid in the four corners of the top.

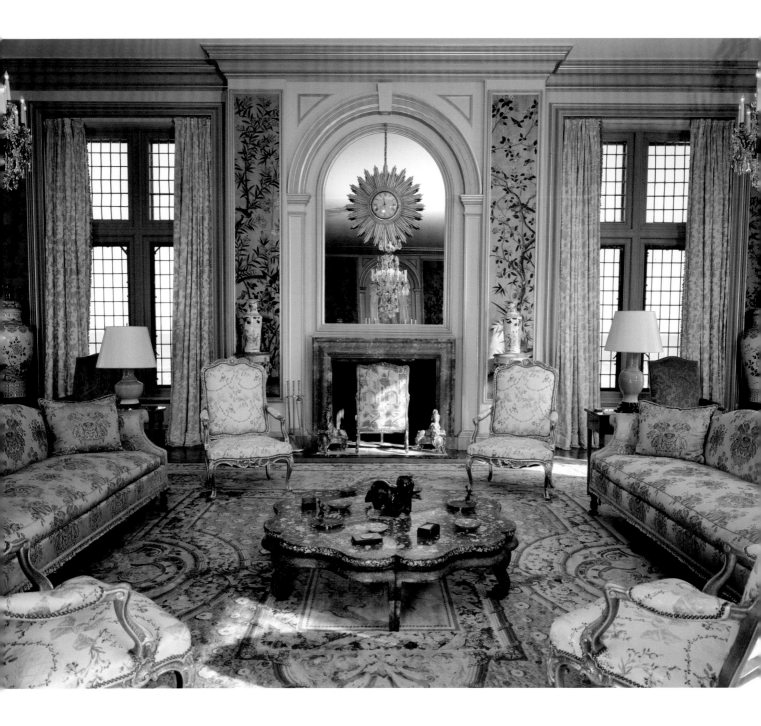

Music Room

The largest addition to Rough Point by the Duke family was the wing to the east, which included the Music Room on the ground floor. This large space was decorated by Doris Duke in the best of taste with antiques carefully sought over decades. The Chinese hand-painted wallpaper was created in the 18th century and is composed of two separate sets of panels. The subtle blue and green tones of the paper and surrounding trim are complemented by the warm gold of the silk curtains, which in turn pick up the gilt ornamentation on the furniture. When the curtains are open, the blue sea and green grass outside create a natural connection to the indoor space.

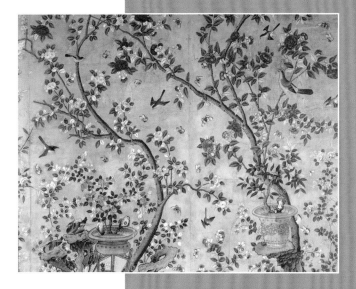

The current decoration of the Music Room was an ongoing project of Doris Duke's. By the mid-1950s, her mother, who had traditionally used Rough Point as her summer place, was in her mid-seventies and frail. She resided solely at the Stanhope Hotel in New York, and all furnishings at Rough Point — even the chandeliers — were sent away to storage, probably at Duke Farms in New Jersey. Miss Duke visited Rough Point with friends in about 1958 to look over the house and consider the new decor. In 1958 and 1959 she bought separate lots of the 18th-century Chinese wallpaper at auction, and these were installed in special removable panels in the Music Room. The trim was painted the subtle green and gold tones that still adorn it today. Furniture and ceramics were collected and interchanged over the decades, and the original quarter-sawn oak floor was replaced with the 18th-century French floor in about 1970. Some of the furniture — that at the west end of the room — was for display only, while the grouping near the fireplace was created for small gatherings before or after dinner. Staff at Rough Point recall the actress Elizabeth Taylor reclining on one of the sofas to ease her aching back, as well as visiting musicians playing jazz on the piano.

The east end of the room is a carefully crafted assemblage, offering the visitor a vista of fine French furnishings and exquisite Chinese porcelains in a unique setting. The floor is antique French oak, in the *parquet de Versailles* style, from an 18th-century house near Paris. The clock that dominates the wall is in the Louis XVI style, built of carved and gilded wood, with the spring-powered works located in the center of the sunburst. The carpets include a French Savonnerie floral rug from the early-19th century in front of the fireplace; a silk, silver and gold East Turkestan Kashgar of about 1800 near the piano; and a Bessarabian kilim at the west end. All of these delicate pieces show

When Doris Duke began her purchases for Rough Point embellishments in 1958, she found some beautiful Chinese wallpaper. Almost two years later, at the end of 1959, she bought another group of panels, different in design, but still similar in color and style to the earlier set.

The paper shown here features large blossoming peony trees, with exotic birds, butterflies, and Chinese vessels. Each panel is more than eleven feet tall, while the scenes vary in width, according to the space on the wall where each was installed. When the curtains are open, the blue and green hues of the wallpaper seem to combine with the blue of the ocean and green of the lawns to create a large, fantastic, and colorful landscape.

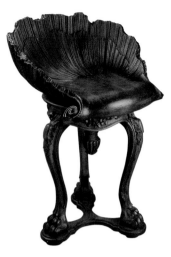

A whimsical and charming piece, this piano stool portrays one of the traditional symbols of Newport, the scallop shell, in its beautifully carved seat. Made in Italy by an unknown cabinetmaker, it dates to about the mid-18th century. Far grander is the suite of Louis XVI chairs and sofa with original, illustrative upholstery from about 1780; this chair features a fable of a bat, a duck, and a bush, and also a story of a dog becoming jealous of his own reflection in the water.

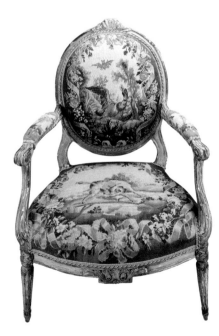

the care that Doris Duke took, not only in finding antiques but also choosing the best examples. She also was greatly concerned for their cleaning, support, and mending over the years, in much the same way as a good museum cares for collections.

One of the gems of the Music Room is the set of Louis XVI chairs, with original pictorial upholstery illustrating fables of the 17th-century French storyteller, La Fontaine. The tales include *The Lion's Share*, *The Fox and the Crane*, and *The Crow and the Pitcher*, all offering moral advice through the animals' adventures. There are twelve chairs and a settee in the set, each with different scenes on the seat and back.

It may be surprising that such formal and elegant furniture would be covered with scenes filled with bats, mice, and other creatures, but it was the height of fashion in the late-18th century. As with some other furnishings throughout the house, Doris Duke found examples with surviving original paint, gilt, and upholstery. The set is marked, "J.B. Lelarge," a superlative French furniture maker in the late 1700s.

To the north side of the room, a Steinway and Sons grand piano fills the alcove created for the purpose. The Steinway here was used almost every day by its owner, although it was still secondary in use to the piano in the Pine Room. Flanking the piano's alcove are two masterpieces of French furniture, a pair of Louis XVI-style ebony and lacquer commodes, bedecked with gilt bronze fittings and red marble tops. The lacquer on these pieces was built up in layers of different colors, and then carved for a three-dimensional effect and a contrast of color, as well. Though these are 19th-century versions of the earlier style, the artisans' work rivals that of the original masters.

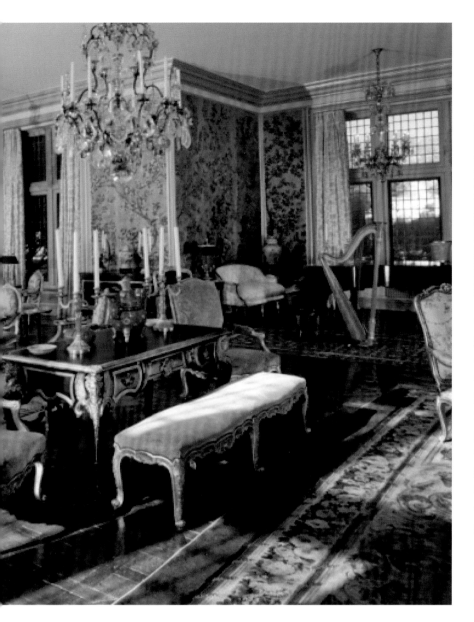

(Above) Central in this scene is one of a pair of George III ormolu musical automatons. It plays a variety of tunes, which can be chosen by turning a jeweled flower. As the music plays, tropical ocean scenes painted on a strip of paper pass behind a ship in the front. The candlesticks are among the few Japanese pieces in the collection; these rare ceramic pieces are in the Kakiemon style (17th-18th centuries) with shishi masks forming the bases.

(Left) In the alcove of the Music Room stands a 1947 Steinway concert grand piano and a 19th-century French harp.

Carefully arranged among the furniture are some of the best Chinese porcelain pieces in the house. In a room as large and artfully arranged as this, most pieces blend in to become part of the harmonious whole; but not the two remarkable mid-18th century Qianlong jars standing more than four feet high that flank the fireplace. A variety of other, smaller Qianlong *famille rose* pieces stand along the walls and throughout the room. And finally, anchoring the south side of the room is another superb set of three Kangxi *famille verte* jars of about 1700.

At each door to the Music Room is a console table holding an 18th-century gilt bronze musical automaton. These bejeweled pieces are made in the form of pagodas, topped by ostriches, hung with prisms, decorated with paste brilliants, and standing on feet in the form of elephants. Probably made by John Cox in England, these were created for the Indian market and fit nicely in the Asian theme set by the wallpaper and porcelains. Flanking the automaton on the north side is the only Japanese porcelain in the room, a wonderful pair of Kakiemon candlesticks, formed as bamboo stems resting on elephant mask tripod bases.

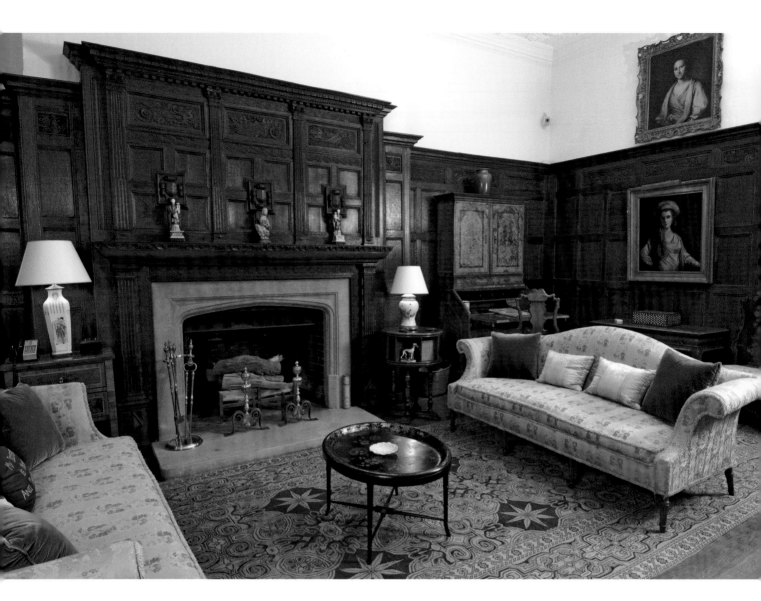

An anecdote about the Morning Room relates Doris Duke's preference for warm temperatures. The fireplaces in the house were all functional and in most cases were laid with enormous, carefully arranged piles of dry wood. They were always kept ready to light, an operation that she insisted on doing herself, and are laid just as they were the last time that she was in residence. The Morning Room was a favorite sitting area after dinner, and one cold evening the guests discovered just how warm it had become when they found the after-dinner chocolates on the coffee table completely melted from the heat of the roaring fire.

Morning Room

Although the Vanderbilts called it the Morning Room, Doris Duke usually used this space as a sitting room after dinner. The Duke family may have kept the earlier designation for this room, but after they added the Solarium to Rough Point, the latter was the obvious choice for reading the morning papers, reviewing the mail, and sipping coffee or tea. The Morning Room, more than most other parts of the house, emulates the English Tudor period, and Doris Duke furnished the room with furniture and artworks in keeping with that theme. As in many large houses in Newport, decorative elements in Rough Point were taken from much older European houses, and in this room the deep brown paneling combines some early elements with later woodwork. One of the original panels above the fireplace bears the initials "IB" and "SB," along with an armorial device and the date 1623. A carved frieze above the main panels includes scrolling foliage and a mythical beast with a large mouth and a long, curling nose. The ceiling, an installation by the Duke family in 1922, is highly decorated with molded plaster elements, featuring bas relief portraits of Alexander the Great and other classical heroes placed in ornamental medallions.

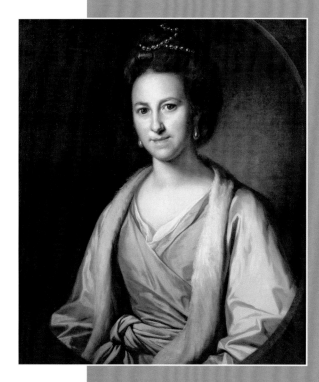

Portrait of Mrs. Hays, Sir Joshua Reynolds (1723-1792), England; oil on canvas, circa mid-18th century. Reynolds became painter to the king in 1784, following many years of painting accomplished portraits that conveyed calm dignity and realistic interpretation of character.

Above the sofa on the east side of the room is one of Doris Duke's favorite works of art and her last major purchase for Rough Point. A marine landscape by Jan van de Cappelle (1624-1679), this painting's title leaves little to the imagination: *A Visit of the Stadtholder Prince Frederick Hendrick to the Fleet of the States General at Dordrecht in 1646.* The scene evokes little of the pomp and grandeur of the title, instead depicting a still, sultry day, with ships drying their sails in the diffuse light of a midsummer sky, amid subdued waterfront activity. The painting retains a contemporary 17th-century frame, heavily carved and decoratively inlaid. It is a very rare survival of the period; later tastes usually demanded the replacement of old frames with the now-pervasive ornately carved and gold-leafed varieties.

Other art works in the room reinforce the emphasis on English art in the house. Portraits include: *Mrs. Sarah Amsinck* (circa 1770), attributed to Sir Joshua Reynolds, the striking and sensitive *Portrait of Mrs. Hays,* also painted by Reynolds; and the charming *Portrait of a Lady in a Red Cloak* (circa mid-18th century), circle of Joseph Highmore. Literally in the midst of these portraits is an Italianate painting in the style of Salvatore Rosa, depicting an estuary filled with ships, in a romantic landscape. Other rare pieces include items that convey Doris Duke's interest in exceptional historic textiles: three needlework pictures of the 17th cen-

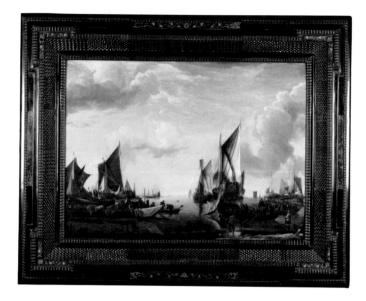

Visit of the Stadtholder Prince Frederick Hendrick to the Fleet of the States General at Dordrecht in 1646, *Jan van de Cappelle (1624-1679), The Netherlands, oil on canvas, circa 1648. A merchant by trade and a painter by avocation, van de Cappelle is nonetheless recognized as one of the foremost marine artists of his day.*

Molded plaster ceiling, Morning Room, Rough Point, circa 1924. Incorporated into the overall design of intersecting moldings are three styles of medallions, portraying Joshua, Hector, and Alexander the Great.

tury depict a Biblical scene, images of royalty, and a romantic scene. In the style of the day, the frames of these delightful pictures were covered in ornamental tortoiseshell. Miss Duke's taste in textiles extended to magnificent carpets located throughout the house, and one of the foundations for the decoration of the morning room is an exquisite pair of 17th-century Portuguese needlework carpets.

The Morning Room furnishings are English with a few notable exceptions. There are two pairs of Dutch rococo side chairs (circa 18th century), with scrolling backs and seat rails. Their ornate shapes are bedecked with marquetry images of classical urns and mythical figures. These chairs contrast sharply with the subdued English furniture and are further distinguished by brilliant yellow silk damask upholstery. Another European piece is a South German baroque walnut and burl walnut fall-front desk, made in the early 18th century. The upper paneled doors reveal an elaborate interior of pigeonholes, drawers, and a glazed cupboard. English furniture in the room includes a variety of chairs in Jacobean, William and Mary, and Queen Anne styles. The three sofas are in the George III style and are covered in reproduction fabrics. An oriental touch is found on the fireplace mantel, where *famille rose* Chinese porcelain maidens (mid-18th century) watch over the room. There is a *guanyin* Chinese mythical figure in the center, one of several in the house. *Guanyin* figures represent an East Asian goddess of mercy and were an important part of Doris Duke's appreciation of Asian art and culture.

The view from the south-facing windows is a dramatic glimpse of the Atlantic Ocean shore, though not as sweeping and grand as the views from the Solarium and Great Hall, with their larger groups of windows. Here one might hear the story of Princess and Baby, the two Bactrian camels that once lived at Rough Point during the summers. House staff recounted that the camels would chew on just about anything they could reach, including some of the leaded windows on the house. That prompted Doris Duke to have exterior acrylic panels installed on every window, partly to protect the house but above all to prevent the camels from poisoning themselves. It is an affectionate statement of Doris Duke's attitudes that when the needs of preserving the look of the house conflicted with the needs of the animals, the animals were accommodated first.

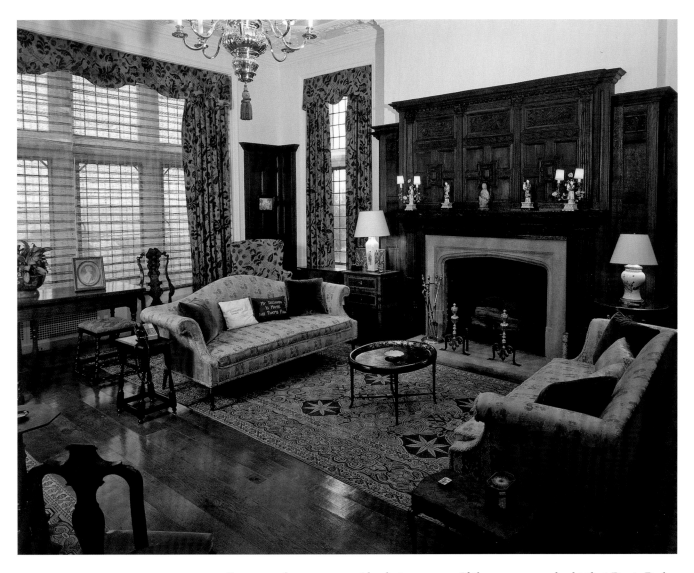

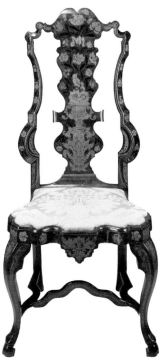

Rococo-style marquetry side chair, The Netherlands, walnut and various inlaid woods, 18th century. Each part of the chair, from leg to crest rail, is not only ornately shaped, but also decoratively inlaid with foliage, urns, and flowers.

If there were any doubt that Doris Duke had a sense of humor, the small pillows embroidered with mottoes show that she was willing to poke fun at herself. A pillow in one of the bedrooms reads, "Be reasonable… do it my way." Two pillows in the Morning Room state, "Familiarity breeds" and "My decision is maybe, and that's final." Once, a prankster placed signs on two new Jeeps for the Duke Farms security department, reading, "Duke Farms Fuzz;" Miss Duke thought it was so funny she kept the signs on the vehicles for several months, to the delight of her staff and neighbors in Hillsborough.

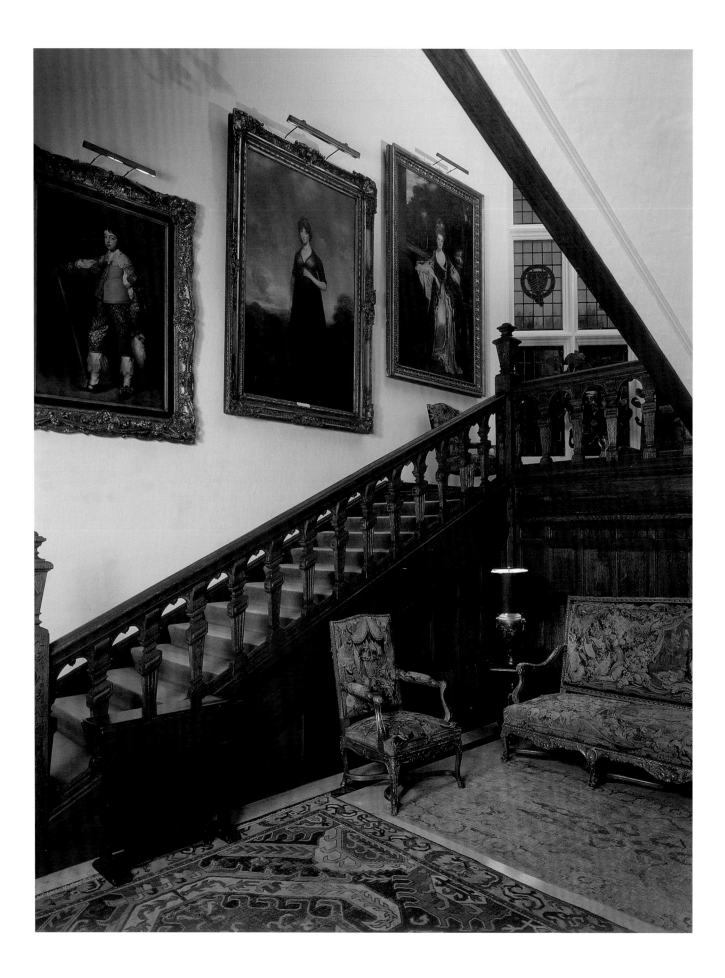

Grand Staircase

A major area of renovation at Rough Point from 1922 to 1924 was the main stairway. The original stairs ascended rather tightly in one straight flight to the second floor, but the Dukes wanted something more grand and perhaps more befitting the English style of the house. Thus, a large bay was added to the front of the house to accommodate a short flight of stairs up to a large, decorative landing and a parallel flight of stairs away from the front of the house to the second floor. The stairway woodwork roughly mimics English oak carvings, but two more elements are of equal importance. The large, open space provided a perfect opportunity to show off an elaborate set of windows depicting the coats of arms of signers of the Magna Carta and, in the center, the arms of the Archbishop of Canterbury, the king, and the pope. Finally, the soaring walls in the staircase offered perfect backdrops for ancestral family portraits, as in an English country house. Lacking noble portraits of their own ancestors, the Dukes followed the lead of many of America's wealthiest families and shopped the world art market for masterpieces of European portraiture.

Ascending the stairs, one first encounters the young King Charles II of England, as painted by Sir Anthony van Dyck about 1640. The young king is resplendent in a highly ornamented suit and walking stick. Following is the *Portrait of Mrs. Charlotte Dennison* painted by another royal painter, John Hoppner, in 1797. Far more regal is the *Portrait of Caroline, Fourth Duchess of Marlborough*, by English court painter Sir Joshua Reynolds, painted around 1780, probably in a setting at the family seat, Blenheim Castle. Next comes *Portait of the Marchioness of Wellesley*, a famous French beauty of her day, shown with her two young sons about 1798. After the picture was painted, it was sent to her husband, who was serving the British Empire in India. Toward the top of the stairs, there is finally a Duke family picture, the *Portrait of Nanaline Holt Inman Duke*, painted by the English artist James Jebusa Shannon about 1905, not long before her marriage to James B. Duke. Beyond her mother's portrait is a painting by John Da Costa of Doris Duke herself. It depicts her at age twelve in 1924,

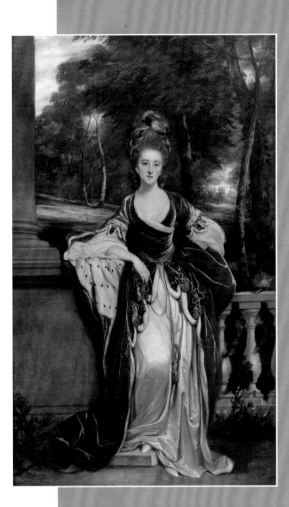

Portrait of Caroline, Fourth Duchess of Marlborough, *Sir Joshua Reynolds (1723-1792), England; oil on canvas, circa 1780. Grand and elegant portraits such as this one, with the duchess in her ceremonial garb, illustrate the rich, formal style that brought the artist deserved recognition as the king's portraitist.*

Queen Anne-style settee, England; walnut, secondary woods with silk and wool fabrics; early-18th century. The elegant curves of the double arch back and outscrolling arms of this piece are complemented by the upholstery fabric of illustrative petit point and gros point needlework.

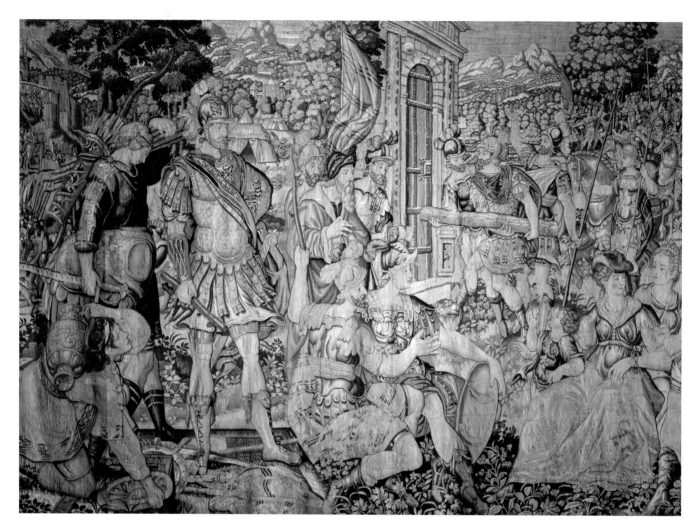

Exploits of the Roman General, Scipio Africanus, *Flanders; silk and wool tapestry, late-16th century. Part of a group of four historical tapestries, this pictorial textile piece shows the great general conquering Carthage.*

the year that the Dukes moved into Rough Point. These two paintings are the only likenesses of any family members kept in Rough Point by Doris Duke, although many photographs of family and friends have been gathered in a central archive at Duke University.

The hall at the base of the stairs was an area that first received Doris Duke's attention in 1958, when she decided to make use of Rough Point as her mother no longer ventured to Newport in the summers. The Renaissance historical tapestries that cover the walls were bought for this room in that year, thus beginning her search for art works appropriate to Rough Point. The tapestries were made in Brussels in the late 16th century. They show important events in the career of the famous Roman general, Scipio Africanus (185-129 BC). Beginning under the stairs, one sees Roman soldiers besieging a city and a soldier with a battering ram attempting to break through a barricade; to the right of the Great Hall door is a scene of Scipio accepting the keys to the city from the conquered Carthaginians. To the right of the Morning Room door is a depiction of the Battle of Zama with the Roman troops of Scipio and the Carthaginian troops and elephants of Hannibal engaged in fierce combat; to the right of the dining room door there is a scene of Scipio receiving crowns and jewels.

A Queen Anne-style walnut settee sits between the two doors, and it exemplifies the overall simpler lines of the period (1702-14). The lines

of the legs are quite complex, but there is an elegance to the piercing in the stretchers. The rich pictorial upholstery fabric illustrates Doris Duke's intense interest in elaborate textiles. On the west side is a 17th-century English oak refectory table, with a waved frieze inlaid with alternating light and dark bands, on baluster-turned legs joined by a stretcher. On the table is a cloisonné enamel-and-gilt metal cylindrical tripod censer, made in China in the 18th century, with a decoration of stylized writhing dragons and a carnelian agate finial. Next to the table are Régence-style chairs, in the French fashion of the 18th century, but intriguingly these are old reproductions made in the late 19th century and covered in panels of late-17th century Brussels fabric showing birds and stylized foliage.

Under the stairs sits a Régence-style giltwood sofa (French, circa 1710-1730) upholstered in early 18th-century Gobelins tapestry, depicting Athena, the Greek goddess of war, fertility, arts, and wisdom. On the sideboard is a reliquary of a female saint containing a fragment of bone. Although the saint remains unidentified, the staff has dubbed her "Saint Cecilia," whose feast day is Doris Duke's birthday and, fittingly, is the patron saint of music.

In the middle of the room is an Italian baroque walnut-and-gilt center table (partially 17th-century, with later additions) with an octagonal top on four upturned dolphin supports that are in keeping with Rough Point's oceanside location. Miss Duke liked to fill a vase on the table with huge arrangements of fresh flowers from Rough Point's cutting garden north of the house.

The painting in the stair hall is the *Portrait of Angelo Poliziano,* in oil on panel. The subject has been confirmed as a copy of a detail from a fresco by Ghirlandaio (1449-1494) in Florence. Doris Duke, however, was certain the canvas was painted by Sandro Botticelli (1445-1510) and went to some lengths to prove it. Regardless of its provenance, it was one of her favorite pieces. A long inscription on the back of the picture, by an Italian art scholar, asserts the Botticelli attribution, but several modern scholars agree that the work is not that of the master, but an effort by an accomplished but thus far unidentified Italian artist about a generation later, approximately 1550.

Portrait of Doris Duke, Age Twelve, *John Da Costa, United States; oil on canvas, 1924. This portrait was painted the year the Duke family moved into Rough Point. Miss Duke recalled being impatient for each sitting with the artist to end, so that she could join her friends at Bailey's Beach.*

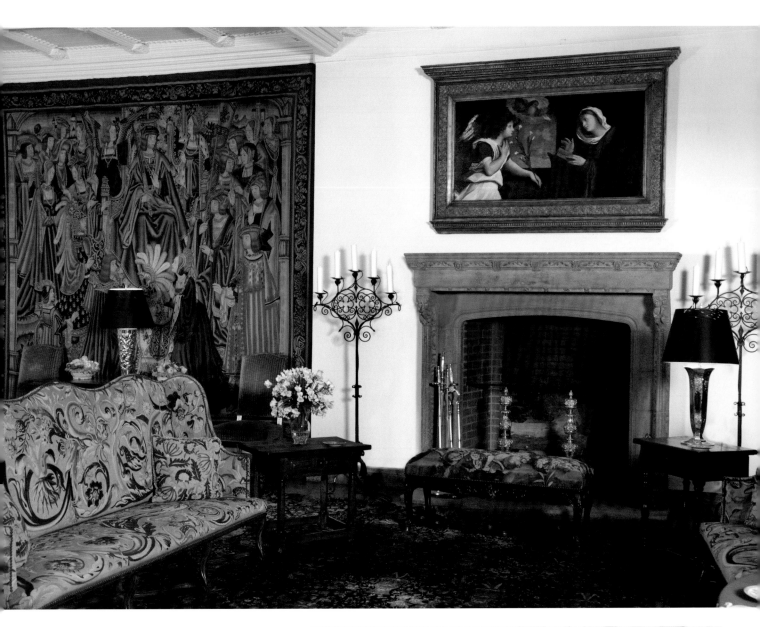

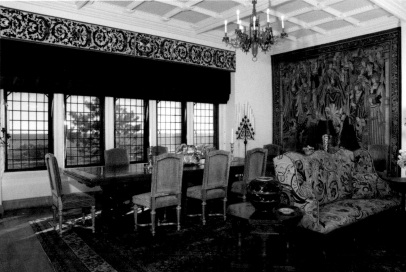

Dining Room

The Dining Room at Rough Point is one of many spaces in the house that was substantially altered by the Dukes and their architect, Horace Trumbauer, in 1922. As built for Frederick Vanderbilt, the Dining Room was a large space, but there was a hallway and at least one small room on the north side. The Dukes decided to clear away the service areas and create a dining room that occupied the full width of the house. The ceiling was replaced with a deeply coffered, molded-plaster, faux wood pattern, in keeping with the English-manorial style of the house. The room is lit by two late-19th century French chandeliers, set in such a way to suggest that the room was meant to accommodate a table seating about forty people with style and elegance. Indeed, for a time, it was used that way by Nanaline Duke. However, Doris Duke did not care for entertaining on a large scale, and certainly now the room arrangement is remarkably intimate.

Straight ahead from the main door, one is faced with a large cast-stone fireplace surmounted by one of the greatest art works in the house, *The Annunciation*, painted by Palma il Vecchio in about 1526, and one of the earliest art works that the Dukes brought here. Matching Régence-style sofas covered in 17th-century fabric flank the fireplace, along with side tables, silver lamps, and small objets d'art. The space looks like a large sitting room, but then one notices a Flemish Renaissance-style table by the seaside windows. Large by most standards, the table easily seats fourteen, but looks small in this grand space. Although fourteen chairs were restored for use here, six more were never updated and are stowed in an attic space. Household staff remember that Doris Duke seldom hosted more than six or eight guests for dinner.

The Dining Room contains three beautifully preserved tapestries, including a lavish Louis XIV-period piece. This tapestry was made in the late 17th century in Beauvais, France, to praise the glory of the king in the style of the day. There are two coats of arms in the center — the royal arms and the arms of Navarre, the king's family seat—flanked by winged nymphs reclining on clouds on a background patterned with fleur-de-lis. Tapestry scholars have suggested that this piece hung at one time in a French royal chateau. A pair of Brussels Gothic tapestries from the early 16th century hang at either end of the dining table. Much less imaginatively woven than the French example, these tapestries crowd many human figures and many other details into scenes of courtly life. As such, they are intriguing pictures of contemporary life, at least among the wealthy and powerful of Europe.

Exemplary of the rare antique textiles in the collection is a Régence room divider screen near the fireplace, made in the French royal Savonnerie factory about 1720. The four woven panels of the screen con-

Fruit Basket, workshop of Andrea della Robbia, Florence, Italy; glazed earthenware, 16th century. A pair of these whimsical baskets adorns the Dining Room, and include not only ceramic fruits and vegetables, but also a friendly looking frog and a small lizard.

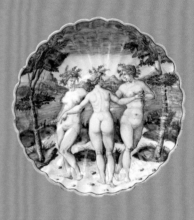

Fluted majolica basin, Venice, Italy; tin-glazed earthenware, circa 1560. In keeping with the narrative style of the time, this piece was not made for practical use, but solely as a support for the illustration of the Three Graces.

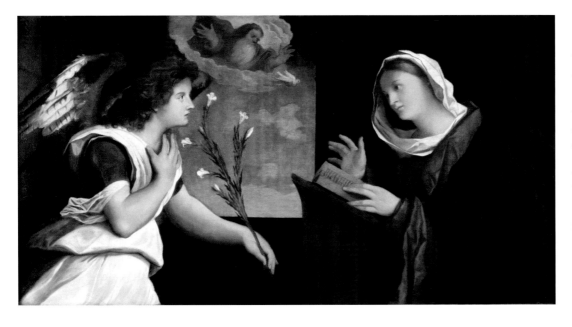

tain scenes from the fables of La Fontaine, which were very similar to Aesop's fables. The style and the subject matter of the screen also relate to the largest furniture group in Rough Point, the Louis XVI chairs and sofa in the Music Room.

One of the most treasured art works at Rough Point is the Renaissance painting, The Annunciation, *hanging over the fireplace in the Dining Room. Painted in northern Italy in about 1526 by Palma il Vecchio (Palma the Elder; 1480-1528), it originally was installed in a side altar of a church in the city of Bergamo, until Baroque tastes called for newer pictures. Family inventories indicate that it was one of the first art works to be hung in the house when the Dukes moved in, and it remained there from 1924 until 2001, when a distinguished art museum in Bergamo borrowed the painting. Museum staff members escorted the painting to Italy for the special exhibition and then safely home again to its accustomed place.*

Oral histories with staff at Rough Point document visits by Imelda Marcos, who was always accompanied by two or more personal guards. The guards did not have their own room, but sat upright in chairs all night in Mrs. Marcos's room, and there always seemed to be an air of mystery about the visits. Part of that may have been due to the fact that television reporters' trucks often sat outside the gates in anticipation of Marcos's arrival, followed by the inevitable planning for a discrete exit when the time came. Mrs. Marcos often liked to sing in the Dining Room just before dinner. The staff called it, "singing for her supper." Privately, Doris Duke was not fond of the serenades, and most dinners were quiet by comparison.

Despite the arrangement of this room for relatively intimate dining, Doris Duke seldom used it during the nights when she dined alone. Breakfast was always in her own room, as was dinner on most nights. Lunch was usually served in the Solarium. Still, the Dining Room was as carefully furnished and decorated as any room in the house and was always available for an elegant dinner, with a south view of the ocean through the windows, and dozens of candles lending a warm glow.

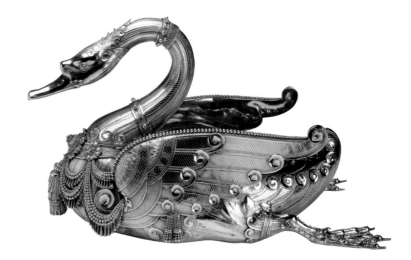

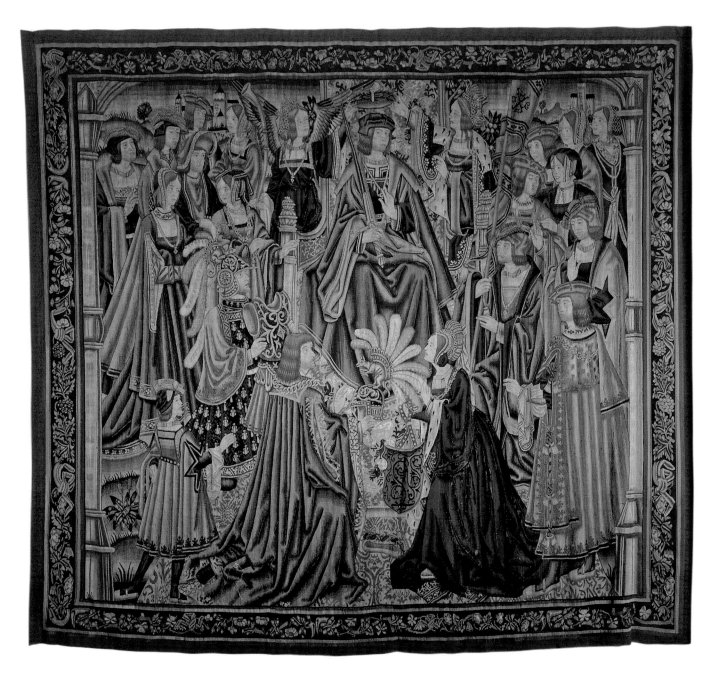

(Left) As Doris Duke traveled from house to house, she often took favorite things — from food items, wine, and art works, to furniture, clothing and dogs — with her, but one of the most widely traveled objects was a sterling silver swan. Tiffany & Co. made this large centerpiece in 1874, and although it was available on order through the company, it appears that few were made. In fact, this may be the only example made in this large size and with all the available embellishments. She bought it at a Sotheby's auction in 1988 and thereafter carried it about on many of her journeys to her homes in Honolulu, Beverly Hills, Newport, New York City, and Hillsborough, New Jersey. Its permanent home is now Rough Point.

(Above) Coronation Scene, Flanders; silk and wool tapestry, early-16th century. This colorful scene in a royal court depicts the grand occasion of a coronation, possibly of the French king, Louis XII.

(Above) Butler's Pantry

There are dozens of cookbooks at Rough Point, and a series of loose-leaf binders with Miss Duke's favorite recipes in them. Some are typed, a few hand-written, and some photocopied from The New York Times *and other sources. But as much as Doris Duke liked her standard recipes, sometimes she liked to be surprised. She once asked her cook, Haddie Awe, for something new, and the special dish was a chicken soup, "Julia Child's Tureen Supreme." It became a favorite, to the extent that the cook became weary of making it. Other beloved recipes included bouillabaisse, said Ms. Awe. "She loved my bouillabaisse…. And she likes pot-au-feu, which is a French stew—ah, she loves that French stew…. In the summer she likes curried chicken with bananas. She loves that dish. And then she likes a lot of soufflés, of course."*

Kitchen

The kitchen at Rough Point was constructed in 1922, when James B. Duke bought the property and commissioned a very thorough renovation. The white ceramic tiles were typical of the period and conveyed the feeling of sanitary conditions; in fact, soil could be easily identified on the gleaming white surfaces. Several decades later, Doris Duke decided to make a few changes to the old design. An interior decorator friend had persuaded her to try the dark blue ceiling and trim, which have now been traditional for many years. The kitchen fireplace was constructed about the same time. If one looks carefully above the fireplace, the arch of an old ventilator hood can be seen. In the 1920s, a large coal range resided where the hearth now sits, and cooking vapors were exhausted up under the hood, into a chimney flue. The grate in the wall still remains over the ventilator opening.

To the left stands a polished and imposing presence, an oak and brass icebox installed during the early renovation. The interior is white ceramic, for the same reasons of cleanliness, and the ceramic structure also helped to contain the water from the melting block of ice. By 1958, Doris Duke had a mechanical cooling system added to the icebox. The compressor and electric motor were placed in the basement, so as not to intrude on the tranquility of the kitchen. Another early appliance is the low, four-square humidor directly adjacent to the hallway door on the right side. James Duke loved cigars and apparently kept an ample supply at hand under the best conditions in this humidor, fittingly covered in white ceramic tile. The kitchen is not extravagant because Doris Duke was not fond of large dinner parties, but it is certainly set up to handle daily dining and the frequent small dinner groups. The full set of copper cookware hanging from the pot rack was a favorite of the cooks, but due to the effects of cooking on the stove and the salt air of the seashore, maids were kept busy polishing them. The entire kitchen was cleaned daily top to bottom.

The Butler's Pantry is just to the east of the kitchen, and there is a pass-through where food could be placed on trays or kept in the big warming oven on the right side. The pantry is furnished with a large icebox, identical to the one in the kitchen and also equipped with mechanical cooling that operates from the basement below. A large sink is thoughtfully placed where the staff person washing the dishes could gaze out at the ocean while elbow deep in sudsy water. In the

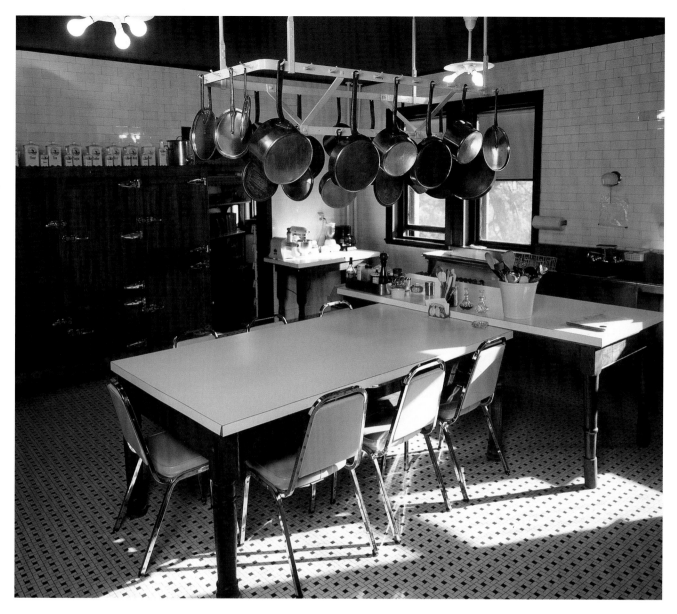

surrounding drawers, cupboards, and steel vaults are all the sets of dishes, breakfast sets, napkins and place-mats, trays, decanters, and serving pieces that a house with modest entertaining needs would require. Out of sight is the silver room, housing a silver service for forty; tea, chocolate, and coffee sets; chafing dishes, serving dishes and platters; salt and pepper dispensers; and silver plates, bowls, tankards, candlesticks, and special utensils. Everything is an eclectic mix of antique pieces and 20th-century items, purchased either by Doris Duke or her parents. Household staffers have indicated that Miss Duke liked having the antiques and enjoyed collecting them upon occasion, but she did not often use the oldest or most ornate pieces. Here, as throughout the main house, everything remains as it was the last time Doris Duke was in residence.

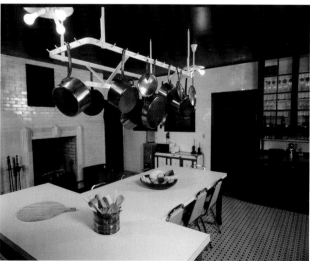

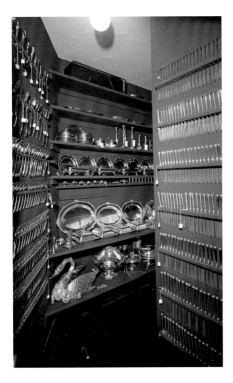

It may be a unique feature of Rough Point that many staff areas had views equal to the best in the house. Often, among all the large Bellevue Avenue houses, utility areas were in the basement, and even when they were above ground level, the view was often to a driveway or service yard. At Rough Point even the staff bedrooms upstairs, and the kitchen, Butler's Pantry, and Staff Dining Room lacked the drama of the formal rooms, but no one could ignore the beautiful marine vistas available through the windows of the staff areas. The Staff Dining Room is a light and airy space, cozy with a large fireplace and bookshelves, where the house staff could relax with a pleasant meal when activities in the house were not too hectic. And, since Miss Duke was often in residence no more than a third of the year, one can imagine that staff life here could be quite pleasant. In general, there were two house staff people on duty throughout the year, and in the off seasons their duties were to circulate through the house, cleaning all the rooms, which were always ready for "The Boss" to return.

When Doris Duke was in residence at Rough Point, the silver closet held all the silver flatware, tableware, and decorations for the house. Each item was kept in its accustomed spot, so it was readily apparent when any piece was moved or missing. Some of the lesser-used items included the antique chocolate pots and toasted cheese pans; one of the latter was partially melted from too much heat on a gas burner. Note the Tiffany swan centerpiece on the bottom shelf — it now resides on the Dining Room table at all times.

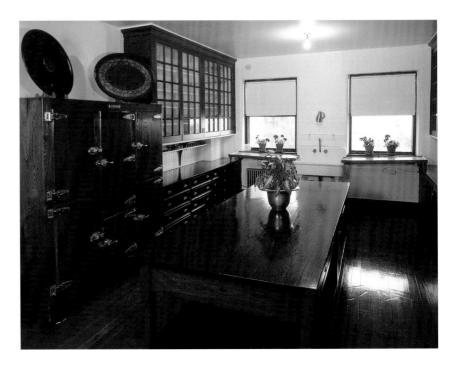

Even at a place like Rough Point, modern technology was adopted when its presence would serve a vital purpose. One such example was the purchase of a fax machine for the house, at a time when faxes were an unusual and special means of communication. Similar machines were installed in all of Miss Duke's houses, and daily business was communicated and transacted between them and Duke Farms in New Jersey. One of the most important uses of the fax was to transmit recipes from one house to the others (Shangri La in Hawai'i, Duke Farms, the New York apartment, and Falcon Lair in Beverly Hills), so that new dishes that she liked would be part of the recipe library in every kitchen.

Pine Room

The second floor of Rough Point was Doris Duke's private retreat within a house that was itself intensely private. The part of this floor that is open to the public presents the most important rooms and gives a clear picture of Doris Duke's choices for decoration and furnishing in her private spaces. Her preference was always for intimate rooms, often a challenge in a building with the vast open spaces of Rough Point, but the second floor lent itself to this desire more easily than the first. The large landing immediately conveys the effect with lower ceilings—ten feet, compared to twelve to twenty-six feet on the first floor. Although her exquisite collection of antique carpets could not be left on the polished oak floors when Rough Point opened to the public, a huge 17th-century English table still stands opposite her bedroom door, adorned with a selection of her favorite Chinese porcelains. Once again, her taste in Chinese art is present in the form of a jardinière and a pair of large punchbowls and the large *famille verte* jars that are especially graceful and rare survivals.

Remaining on the table are five stacks of magazines and catalogs that she read and referred to regularly. House staff said that she would keep materials on the table as long as she was interested in them, and then discard them as she pleased. Catalogs from the major auction houses of the world often include items that she bought for collections at Rough Point or for the Newport furniture collection at Samuel Whitehorne House — also in Newport — or for her houses in New Jersey, New York, Beverly Hills, or Honolulu. Her favorite magazines included: *Vogue, Apollo, House and Garden, Connoisseur, Antiques,* and *Architectural Digest.* Although she was not a constant reader of books, Doris Duke read three daily papers, *The New York Times, The Wall Street Journal,* and *The Washington Post.*

The decoration of the hall itself is simple and elegant in an informal way that contrasts with the imposing first floor rooms. The white-painted walls and trim help to keep a feeling of light in an area with few windows, all north facing. Below the chair rail is a simple, cheerful strip of green trellis wallpaper, printed on a white background. This paper makes a telling connection with one of Doris Duke's best friends, Aletta Morris (later Alletta Morris McBean), whom she knew from childhood in Newport. Chepstow, the McBean house just down the street from Rough Point, has the same wallpaper design in several areas. The carpet made to match the wallpaper colors is a reproduction to replicate the threadbare original. The art works on the second floor are mostly antique prints and drawings, generally depicting flowers or mythological and classical scenes.

The Incas, *Joseph Dufour et Compagnie (1797-1835), Paris, France; ink on paper, circa 1820. The faltering Dufour wallpaper company began producing panoramic papers in the early 19th century and had great success with a variety of scenes, which were considered exotic, but also were thought to be educational and entertaining. Some, like* The Incas, *were based largely on artists' conceptions, thus plants were inaccurately portrayed and details such as architecture and clothing were often more fanciful than historically accurate.*

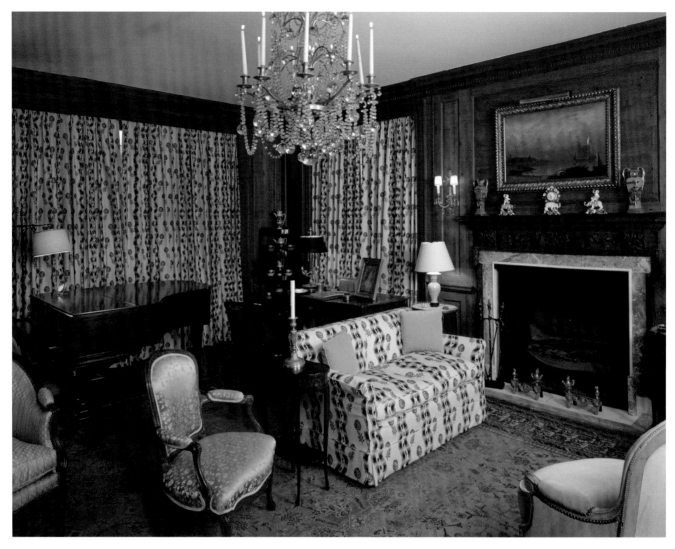

The Pine Room appeals to the senses
as a cozy sitting room, with its large
fireplace and pine cone-print curtains
and upholstery. Above the mantel is one
of the few American paintings in the
house, The Reef Near Norman's Woe,
by Fitz Henry Lane (1804-1865), circa
1860. The picture was given to Doris
Duke by Alletta Morris McBean, a life-
long friend in Newport, and a collector
of Lane's work.

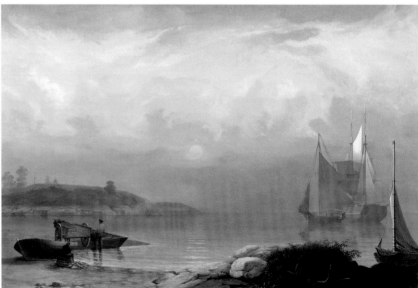

The furniture in the hall is really incidental to its use, and so is decorative, rather than serving a practical purpose. However, as decorative pieces, they are well chosen. Two George III satinwood and marquetry tables, walnut wall brackets, and carved and gilt mirrors share the hallway with upholstered benches and chairs of similar styles.

The Pine Room adjoins the hallway and offers yet another contrasting and unique decorative style. Twenty-seven imported

Régence-period panels in a clear natural finish line the room, along with carvings and moldings, giving the room a very warm, cozy feeling. While the Pine Room looks like a pleasant study or sitting room, it was used almost exclusively as Doris Duke's music room on the second floor. Although the concert grand piano in the formal Music Room was the better instrument, she preferred to play and practice in the Pine Room, using the Knabe baby grand piano on a daily basis. The big Sony reel-to-reel tape recorder stands nearby, just as it did when she recorded her own compositions and arrangements, so she could listen to them and make further refinements. A small assortment of sound recordings of her singing and playing has been found in the Rubenstein Library collections at Duke University.

Doris Duke's passion in instrumental music was jazz, which she loved to play herself, and she also occasionally invited jazz musicians to Rough Point. Pianist Joe Castro was a good friend for many years, and for a brief time Miss Duke had her own recording company, Clover Records, primarily to publish Castro's music. She also loved to sing, sometimes joining a Baptist church choir in New Jersey. The choir director said that she had a soft voice, not really suited to solos, but she did well with the group. She practiced her singing regularly with a voice coach from Brooklyn, who traveled to either Duke Farms or Rough Point to instruct her student.

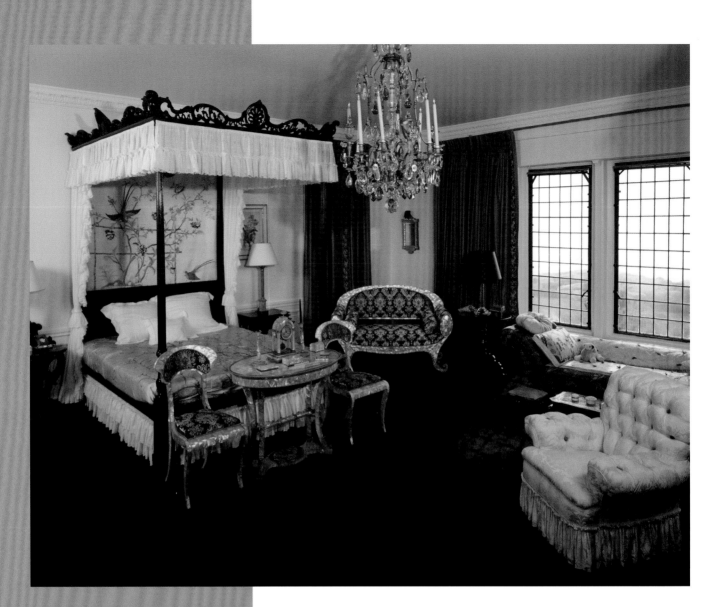

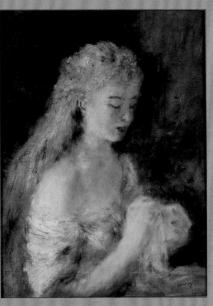

Up to about 1975, Doris Duke's bedroom was decorated almost entirely in purple. The annunciators for the staff call bells still list it as the "Mauve Room." At about that time, though, she decided to redecorate and had the Newport Restoration Foundation paint crew come in and paint the mauve walls yellow, as they are today; the purple carpet was dyed black. Anchoring a corner of the room is a tall, fall-front secretary, aglow with mother-of-pearl on the outer surfaces, and inlaid with ivory, tortoiseshell, and exotic woods throughout the interior. About the same time that the room was first being redecorated in 1959, Doris Duke purchased the only painting in the room — the small Renoir that hangs in front of a large mirror over the fireplace.

Miss Duke's Room

Doris Duke's bedroom was more than a sleeping chamber. She began her day there with breakfast in bed, and then would greet all of her dogs before she arose for the day. Even her very large Malamute, Kimo, would come in and often climbed on the bed after breakfast, upsetting the dishes and causing chaos. She had the greatest forbearance toward her dogs, and their affection for her was unquestioned. Activities during the day often included a swim in the ocean from Midship Rock, just to the right of the ocean view from the bedroom window. Without steps, ladders, or a smooth beach, Doris Duke swam daily by climbing down the weed- and barnacle-covered rocks into the water and back out again. Although a groundskeeper was always on duty at the gate in the fence nearby, she never requested help getting in or out of the water, even in her seventies.

A pair of tall candelabra flanking the double doors to the master bedroom at Rough Point herald the special sanctuary created within. Even in a house filled with Louis XVI-period furniture, the candelabra stand out; they are covered in lustrous mother-of-pearl, with ten candle arms and figure of Victory on top of gilt bronze. Made in Paris about 1810, these give the visitor a hint of Doris Duke's motif for decorating her own bedroom.

Stepping into the room, one is struck by the elegant contrast of the black carpet with the yellow walls and the furniture and fabrics. One can only imagine the impact of the room before about 1975, when the walls and carpet were all purple. The curtains and a daybed are both covered in tones of purple, and there is furniture upholstered in purple more brilliant yet. Six side chairs and a settee are covered in bright purple and metallic gold fabric, and all of their frame surfaces are faced with mother-of-pearl. This rare suite of furniture, made in Vienna by Johann Tanzwohl about 1820, also includes two console tables, two wall mirrors, a center table, and a writing table, all covered in glimmering mother-of-pearl. This suite may have originally belonged to King Ferdinand VII of Spain. The smaller tables hold various mother-of-pearl garnitures, lovingly collected by their owner during her world travels over the years: a clock, candlesticks, a desk set, and small boxes. A tall and imposing secretary-bookcase of separate manufacture stands next to the bed, its surfaces covered in a combination of mother-of-pearl, ivory, tortoiseshell, and exotic woods. It was probably made in Peru in the early-19th century and is a rare survival of South American furniture.

The mother-of-pearl pieces are overwhelming at first, but a closer examination of the many small, personal touches in the bedroom will hint at the personality of Doris Duke. On the secretary are a group

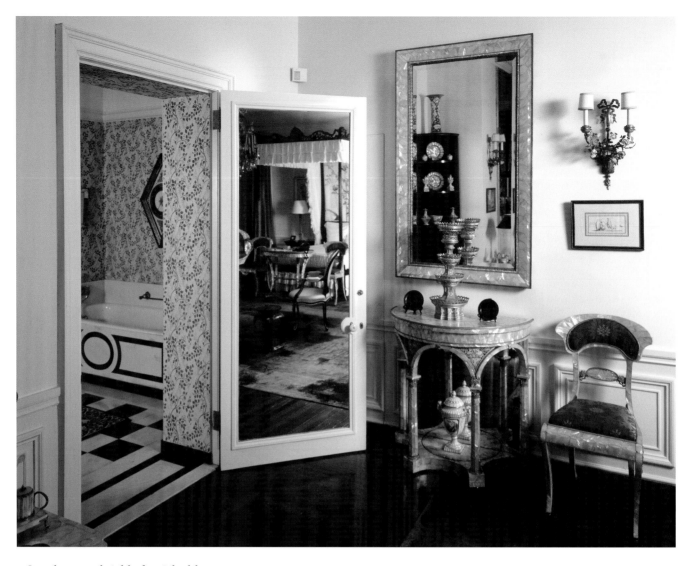

In a large and richly furnished house such as Rough Point, a room that takes the visitor by surprise must be either particularly lavish or unique in some way. Certainly, the master bedroom, with its twelve-piece suite of mother-of-pearl covered furniture is almost dream-like in its rarity. The Austrian, early-19th-century suite of sofa, tables, mirrors, and chairs is augmented by a large secretary bookcase made in Peru in the same period and many small pieces, from dishes to candlesticks. The subdued shimmer of the mother-of-pearl, contrasted by purple and gold upholstery and the black carpet, conveys a stunning example of Doris Duke's taste for her personal chamber.

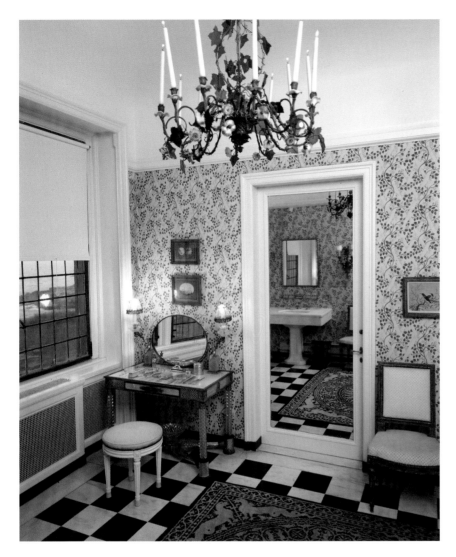

of three small, silver loving cups — trophies of her childhood days at Bailey's Beach, just down the road. Dancing the tango, playing tennis, and constructing sand sculptures are among the subjects of the twelve little trophies in the museum collection. Some of these activities she shared with her good life-long friend Aletta Morris, later Alletta MacBean. Mrs. MacBean was one of the founders of the Preservation Society of Newport County.

On the lacquered breakfast table is an array of small objects such as any traveler might bring home, and yet this wealthy collector of the finest antiques had these souvenirs spread out on a table in her room—a fish carved from a seashell, ceramic and glass dishes, and snuff boxes of silver and porcelain. They are touching reminders from a life spent in traveling across the world.

The finishing touch for this very personal room is a small painting by Pierre-August Renoir (1841-1919), *Fille Cousant (Young Girl Sewing)*, painted by the Impressionist master in 1875. This was one of the few late-19th century paintings Doris Duke owned, and she purchased it in 1959, when she was looking for some of the major decorative pieces for the house. A wonderful example of the artist's light palette and delicate brushwork of that period, it was painted eleven years after Renoir gained public recognition at the official Paris Salon.

Adjoining the master bedroom is a bathroom equipped with some splendid furnishings. The term "bathroom" is entirely inadequate to define the elegance found there. There is a whimsical French chandelier, with scrolling bronze arms and tendrils, bedecked with green glass leaves and colorful porcelain flowers. The sink and bathtub have faucets and spouts in the form of dolphins. Although this tub does not offer hot and cold running salt water, a large antique tub in the adjoining Blue Room does. Doris Duke firmly believed in the beneficial effects of seawater, so her indoor pool in the basement and the Blue Room tub offered salt-water bathing in ocean water free of any chemical treatment. Over the bathtub is an antique French barometer, decorated with a wonderful reverse-painting-on-glass and gilt dial. Although it was no longer functional, some of the house staff set the barometer to match Miss Duke's mood on any given day, from "Tempête," or tempestuous, to "Beau Temps," or good weather. She never seemed to notice this signal of her demeanor.

Even this small room has its share of exceptional furniture. There are two Empire cut-glass pieces, made in France about 1810. A small pedestal-base table serves as a lamp stand, while a sparkling dressing table shows off thirteen pieces of a particularly elegant gold dresser set from Tiffany and Company, circa 1930. The dressing table strongly resembles an even more opulent piece in the Louvre and is thought to have been made at l'Escalier de Cristal — "the Crystal Stairway" — in Paris, circa 1825.

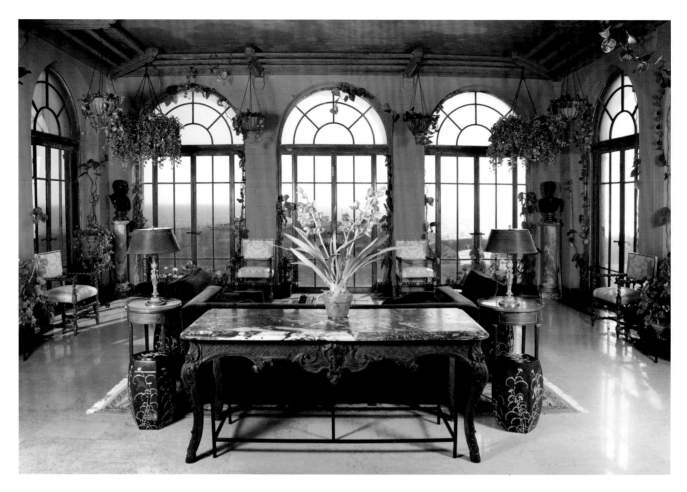

The Dukes added the Solarium
during the renovations of 1922.
Architect Horace Trumbauer
designed the room to resemble
and outdoor space. The rusticated
interior walls appear to be limestone,
and there is a pergola around the
sides for hanging plants. Finally,
a sky scene painted on the ceiling
completes the feeling of being
out-of-doors.

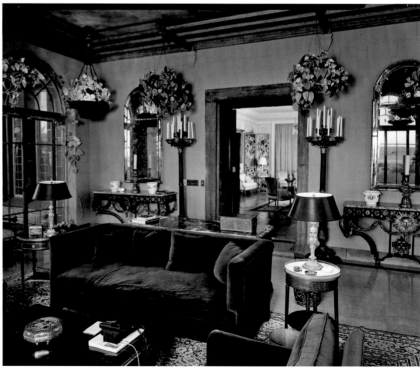

Solarium

The Solarium may be the most striking room in Rough Point, which is a strong statement. A great deal of one's first impression of the room depends upon the weather. Usually though, the south-facing Solarium is very bright in contrast to the subdued lighting in the surrounding rooms. The arched doorways, glazed top to bottom, frame a view on three sides that combines land, sea, and sky in unique ways. The room really gains its impact and drama from the outdoors, not from its furnishings.

In function the Solarium is a comfortable sitting room — where, in fact, Doris Duke often took lunch, made phone calls, met with the board of the Newport Restoration Foundation, and conducted other business. To the east of the Solarium the view is of Easton's Bay, where the seaside homes in the Bellevue Avenue area are lined up along the Cliff Walk. Off in the distance are Sachuest Point and Second Beach, Little Compton beyond that, and Cuttyhunk a bit out to sea. On a clear day there appears on the horizon a vague line that is Martha's Vineyard. The straight-ahead view is a rocky ravine descending to the ocean, under a reproduction of the original stone bridge on the Cliff Walk, and a wide, often empty horizon on the Atlantic Ocean. Toward the west are some reefs and rocks, including the small promontory of Midship Rock, where Doris Duke swam in the ocean. There is no beach and no steps to the sea, but even into her seventies she dove from the rocks into the water and found a way back out again, over the rocks, barnacles, and seaweed.

The furnishings in the Solarium are generally fitting for an informal room in a formal house. Two overstuffed chairs and a sofa covered in brown velvet comprise virtually the only group of modern furniture in the house. The carpet is a replica of the antique Asian original (it was removed when Rough Point was opened for tours), with a light, neutral background and floral scrolls in black and brown. Two Roman-style bronze busts sit atop purple-streaked gray and white marble columns flanking the southern view. The ceiling is painted with a sky-blue background and clouds, and a pergola around the sides gives the impression that one is standing in a courtyard. Rows of plants and some climbing vines help to complete the feeling of a space that could easily be outdoors.

Doris Duke was renowned for her love of animals, and she usually had eight to ten dogs at Rough Point, many of which relaxed in the solarium with their mistress. The last of her dogs was a Shar Pei named Chairman Mao, who survived until 2003. The two camels also died in the early 21st century.

The best tales about the Solarium involve Doris Duke's animals, and not just the Malamute who sidled up to Jacqueline Kennedy Onassis's plate and ate her lunch at one gulp. Rough Point was also famous for its camels for a few years. Doris Duke bought a Boeing 737 plane in 1987, and the deal included a pair of camels from the Middle Eastern plane owners. The two Bactrian camels, Princess and Baby, lived at Rough Point each summer, and sheltered under a large tent next to the Solarium. Guests could feed them graham crackers through a "camel gate" in the French doors. Although hikers on the Cliff Walk reported seeing giraffes, llamas, and other exotic creatures, there were only camels at Rough Point.

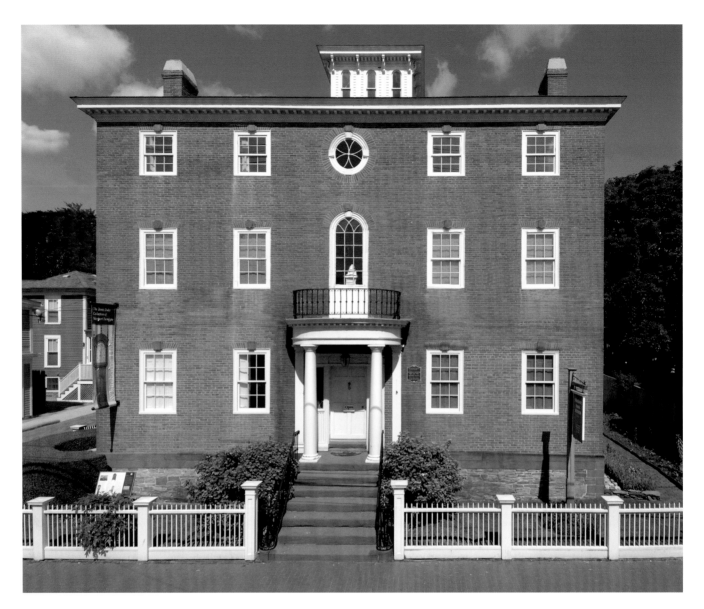

Samuel Whitehorne House was one of the last buildings restored by Doris Duke under the Newport Restoration Foundation. It opened to the public in 1975 as a museum of Newport furniture, and it contains the largest collection of locally created masterpieces in the city.

(Right) This cupboard-base tea table is attributed to John Goddard (1723/4-1785), one of the master cabinetmakers in Newport in the mid- to late-18th century. The shaped drawer sides were each cut with the greatest precision from one piece of wood. All the primary wood is Caribbean mahogany, including the top, which was fashioned from a single, very wide board.

Doris Duke and the NRF

In 1968 Doris Duke began her large scale efforts in historic preservation with the founding of the Newport Restoration Foundation (NRF). Her love of good craftsmanship and aesthetic detail combined with her genuine concern for the rapidly disappearing architecture of 18th-century Newport.

Doris Duke, ca. 1965

In the 1960s Newport had within its borders one of the largest collections of original 18th-century architecture anywhere in the country, but this wonderful historical asset went largely unrecognized, as it had for decades. Newporters had always made do with old structures rather than building new, and most of the city's old houses had slowly deteriorated into tenements and cold-water flats for Navy and industrial housing. By the mid-20th century, the local architectural heritage was tattered indeed. During this time, residence after residence was routinely demolished, often in the destructive guise of urban renewal. These losses started to reverse in the mid-1960s when a very successful grass-roots organization called Operation Clapboard rescued almost sixty early houses in Newport by finding interested private preservationists, who would purchase important houses and then restore them appropriately. There was, however, a limit to what most private efforts could achieve given the huge scale of the task.

The possibilities for more extensive preservation efforts came to the notice of Doris Duke, and in 1968 the Newport Restoration Foundation picked up where Operation Clapboard's efforts left off. With her enormous resources Miss Duke undertook the preservation of many of the most deteriorated structures from the 18th and early-19th centuries. At the height of its efforts, the Foundation employed more than seventy architects, painters, carpenters, and other skilled artisans. Many of the houses on which they worked had to be moved quickly in order to escape the wrecking ball. Although most of the structures were from Newport, there are a few that came from out of town and three that were from out of Rhode Island altogether.

Most NRF projects were the structures that were in the worst condition and were unlikely to be saved by anyone who was not prepared to invest considerably more capital than the completed house was worth. It was not unusual for the Foundation to purchase a house for $10,000 and invest an additional $80,000-$100,000 when the market value after restoration was only $50,000.

By the time that Miss Duke and the Foundation stopped actively renovating houses in 1985, NRF craftsmen had lovingly restored eighty-four houses, or roughly one quarter of Newport's 18th-century housing stock. The NRF continues to own, maintain, and preserve the houses that were originally restored by Doris Duke's generosity. Although preservation was only a minor interest before she founded the NRF,

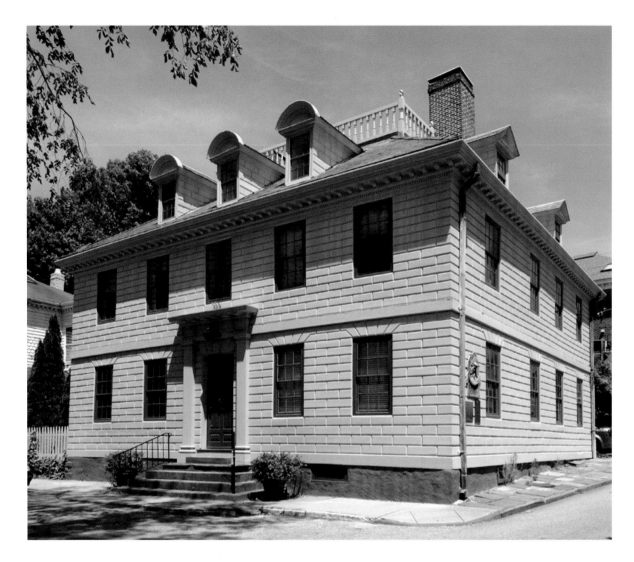

Vernon House came to the NRF as a generous bequest from the late Margaretta Clulow in 2009. One of the gems of the Foundation's collection of 18th-century houses, it is a rare survival employing rusticated wooden siding. Interior details include extensive, carved trim, and Chinoiserie-painted walls in the parlor.

The Sherman Mill, an important utilitarian building of the early-19th century, was brought to Prescott Farm along with several other "orphan" buildings by Doris Duke in the early 1970s. Originally conceived as a living history museum, the property is now used by the NRF for various education programs and special tours.

afterward it was a passion. She was personally vested in the preservation of each house and often offered her opinion on interior and exterior colors from the historically researched color charts. Through the remainder of her life she donated more to historic preservation activities than to any other of her many philanthropic pursuits. The NRF book, *Extraordinary Vision: Doris Duke and the Newport Restoration Foundation*, gives a full description of the Foundation and its creation, along with an image and written description about each house in the collection.

In addition to buildings, Miss Duke also started collecting 18th-century Newport furniture for the NRF, mostly between 1968 and 1975. Her eye for quality — and that of her agents — was excellent, and she assembled an outstanding collection of mid-18th century Newport furniture. This fine collection of American decorative arts was placed in the Samuel Whitehorne House, which was subsequently opened to the public as a museum and remains another popular public site of the Foundation. It is one of the only places in which classic Newport furniture can be seen in its native environment.

Today the NRF is a vital and lively organization. Its collections include one of the largest groups of early vernacular American architecture anywhere in the country as well as Asian and European fine and decorative arts. It is a preservation and museum organization whose creation and continuing vitality are the remarkable legacies of Doris Duke. She was someone who saw the depth and breadth of Newport's history, and through her extraordinary vision and generosity chose to hand on the city's past to future generations.

The NRF continues to plan and take on new challenges, and a signal major achievement was the re-building of the city park at Queen Anne Square for the City of Newport. Designed by Maya Lin, Edwina von Gal, and Nicholas Benson, the park has become a jewel in the center of Newport and a peaceful place to relax for residents and visitors alike. In other endeavors, the Foundation is expanding its initiatives for public engagement, in programs from school visits to the museums, to scholarly research and publication. In these areas and many more, the Newport Restoration Foundation carries forward the legacies of Doris Duke.

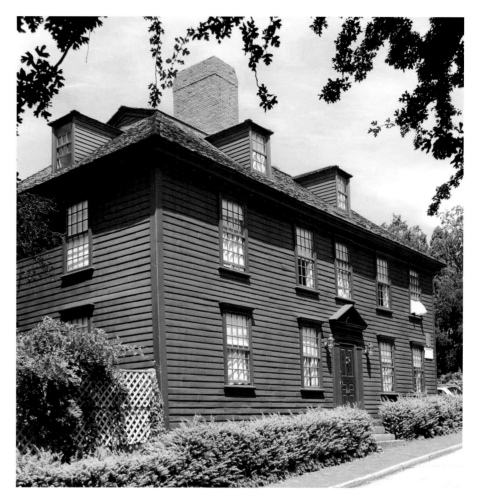

The Dr. Cotton House at 32 Church Street is but one of more than eighty buildings the NRF restored in the process of preserving Newport's 18th-century buildings and streetscapes. After its acquisition from the Newport Redevelopment Authority in 1974, it was moved from its location in the middle of a parking lot to Church Street, adjacent to Queen Anne Square.

"...to early, after church, Joulie and I read
...studie and later took a lovely walk
among flowers. Talked in evening."
Anna F. Hunter's Diary, 189...

Doris Duke herself, through the NRF, created, paid for, and built the first Queen Anne Square as a gift to the City of Newport in 1978. The Newport Redevelopment Authority helped to coordinate acquisition of titles to all the properties, most of which were commercial, and some of which were burned out or derelict. Miss Duke's concept included a number of ocean boulders studding the greensward, and lush flowerbeds with seasonal blooms. The grass remained, but most of the boulders were removed in the name of safety, and the flowerbeds were eliminated in the name of economy.

Thirty-four years after the park's dedication, it was renewed and refined under the auspices of the Queen Anne Square Maintenance Trust, an offshoot of the NRF. The endeavor was supported by a number of generous donors. Artist Maya Lin designed three stacked stone foundations, which represent actual locations and footprints of buildings that existed on the site during three centuries: the 18th to the 20th century. Additional new elements in the park include paved pathways, benches and other seating areas, highly efficient lighting, and a water table. From its opening day, the renewed Queen Anne Square has been a delight for Newport residents and visitors alike.

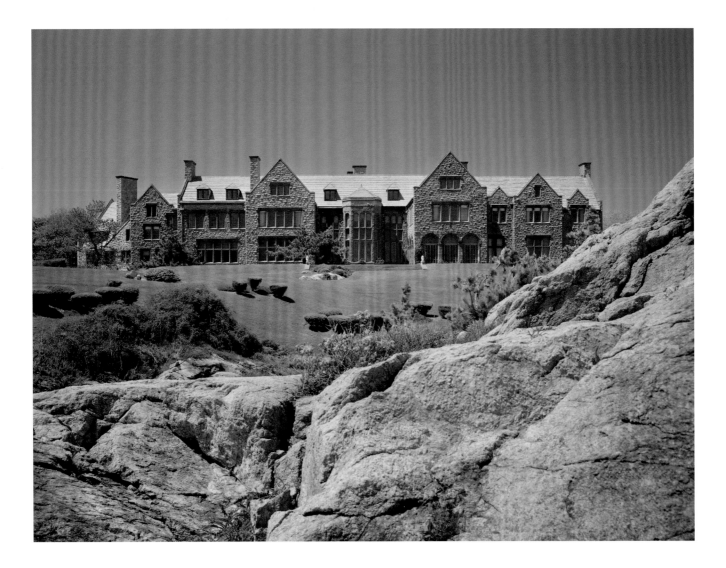

Photo Credits

Newport Restoration Foundation Archives, *4-5, 8, 18, 57*

Warren Jagger Photography, *Cover, 6-7, 11, 64*

Vanderbilt Mansion National Historic Site, National Park Service, *9*

The Preservation Society of Newport County, *10*

Doris Duke Charitable Foundation Historical Archives,
David M. Rubenstein Rare Book & Manuscript Library,
Duke University, Durham, North Carolina, *12-15, 59*

Richard Walker, all interior and object images, exterior images *16, 58, 60, 61*

Frederick Law Olmsted National Historic Site,
National Park Service, *17, 19*

Alexander Nesbitt Photography, *62-63*